How to Draw
Super Cute Animals

Copyrighted Material

Cat

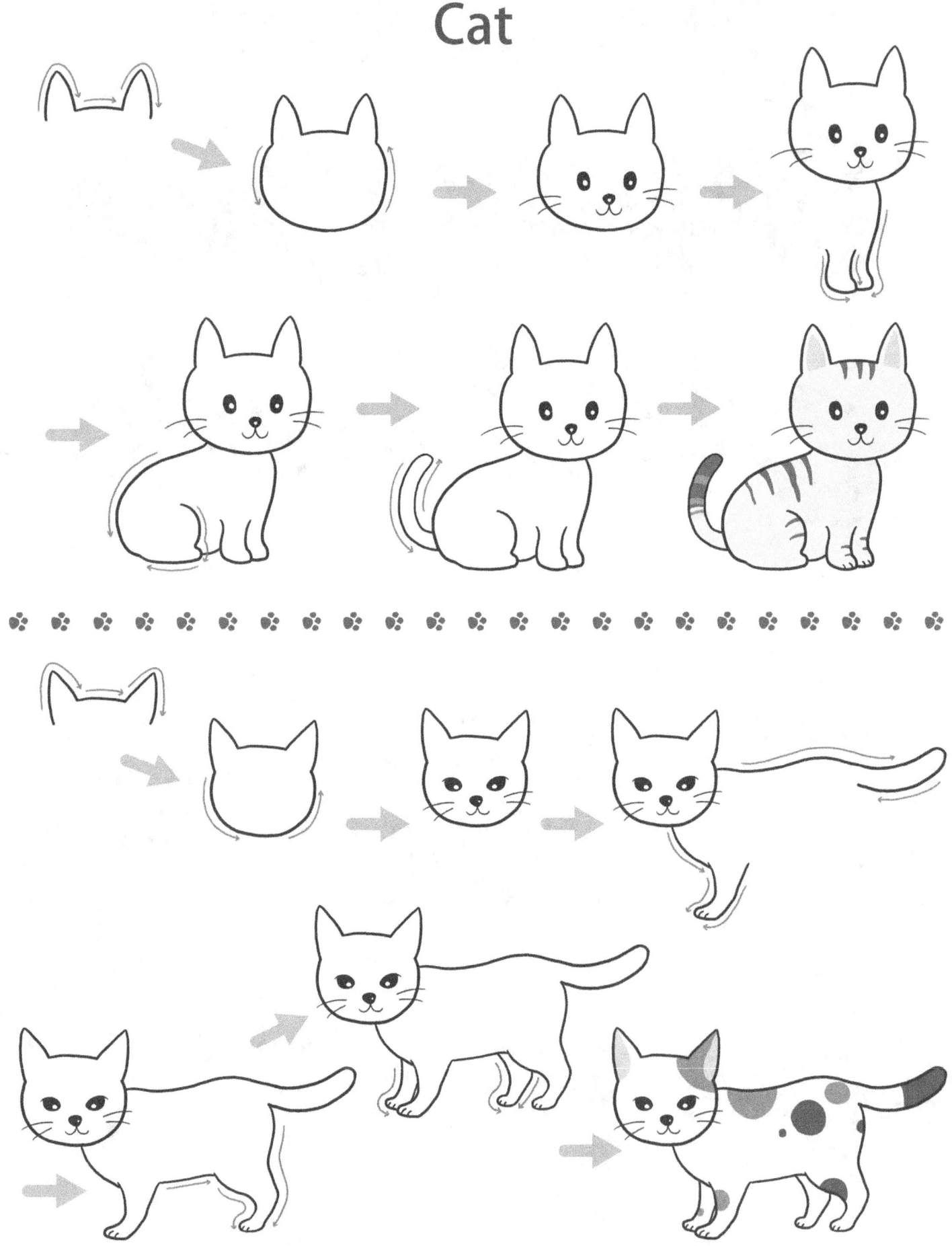

Dog

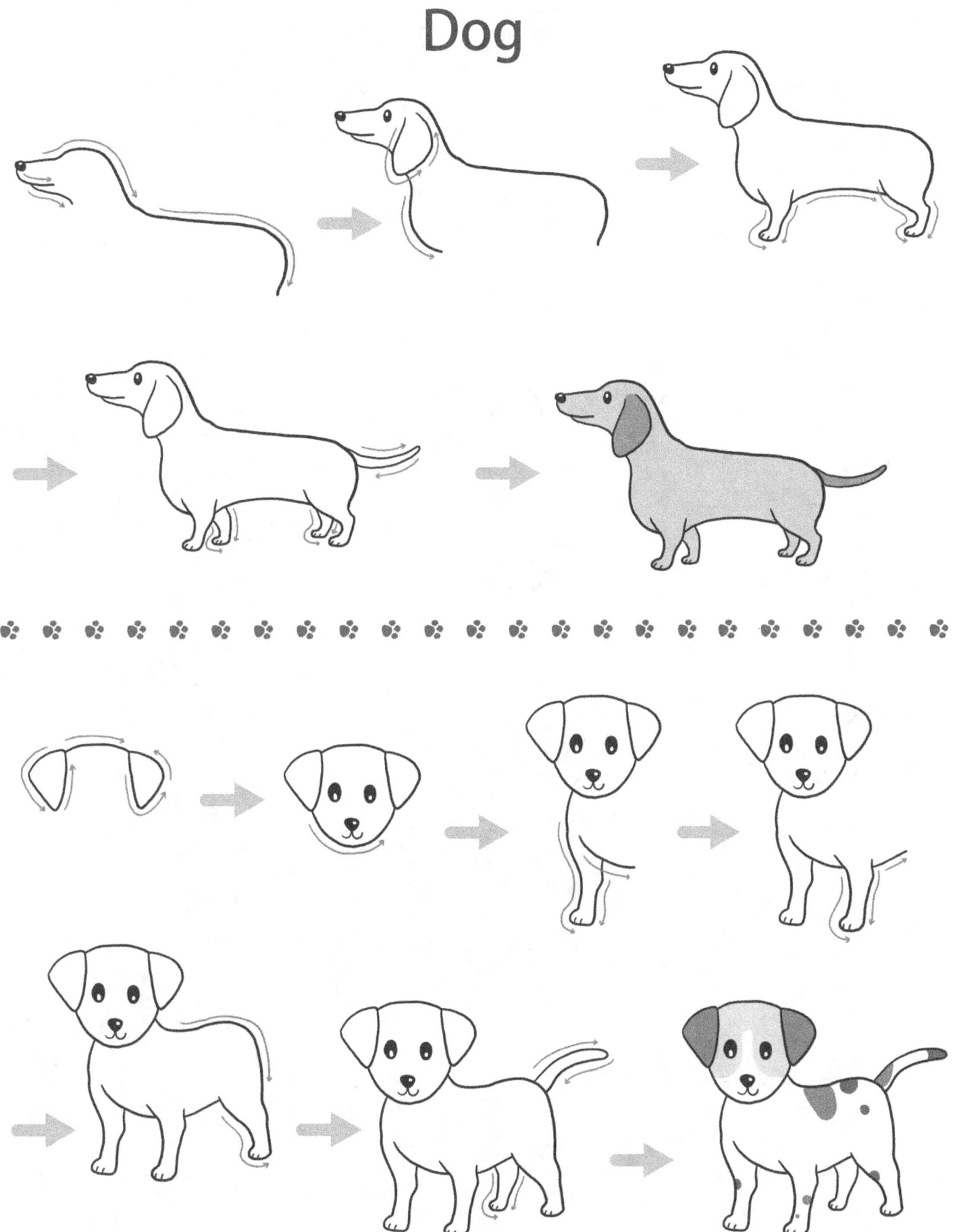

Rabbit

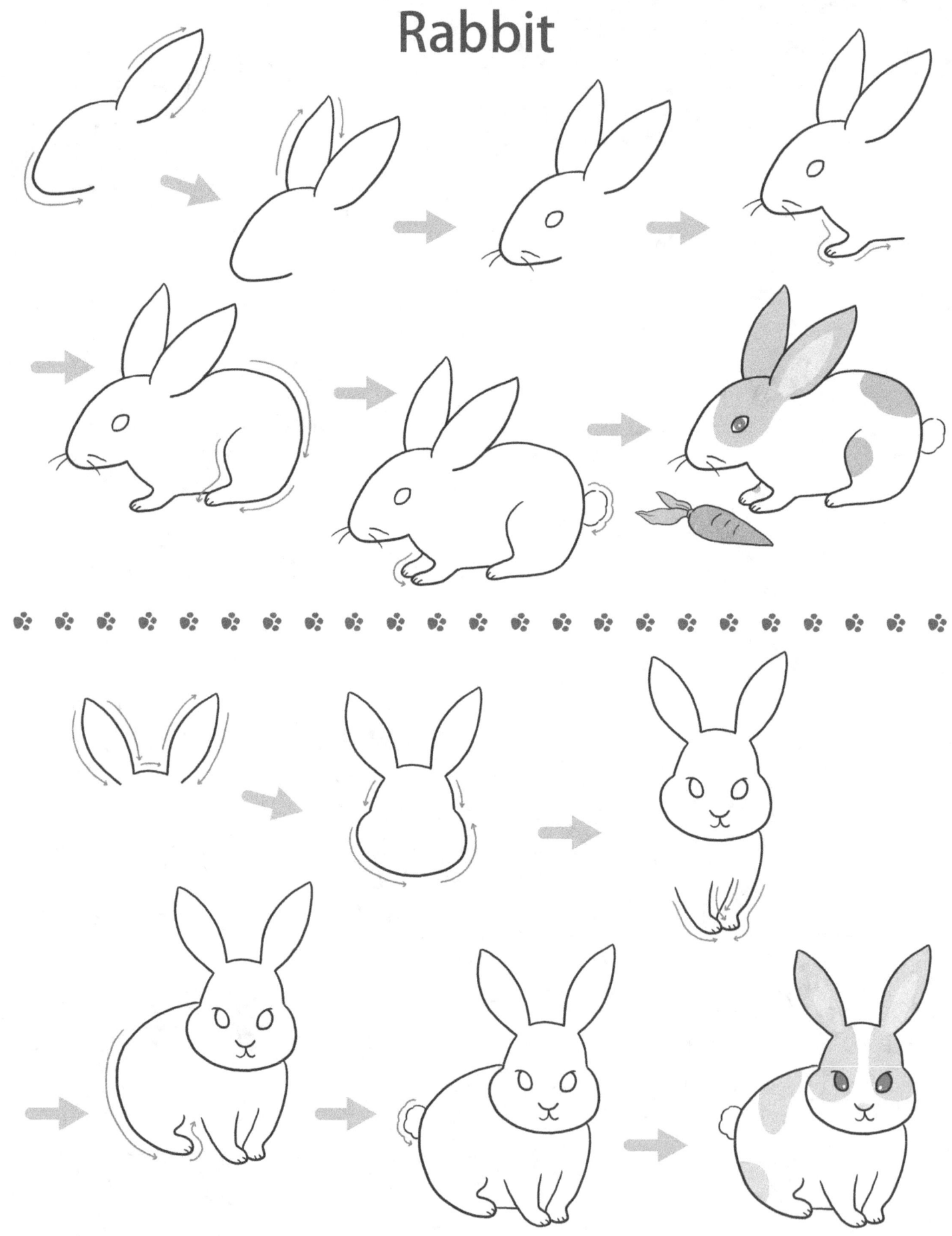

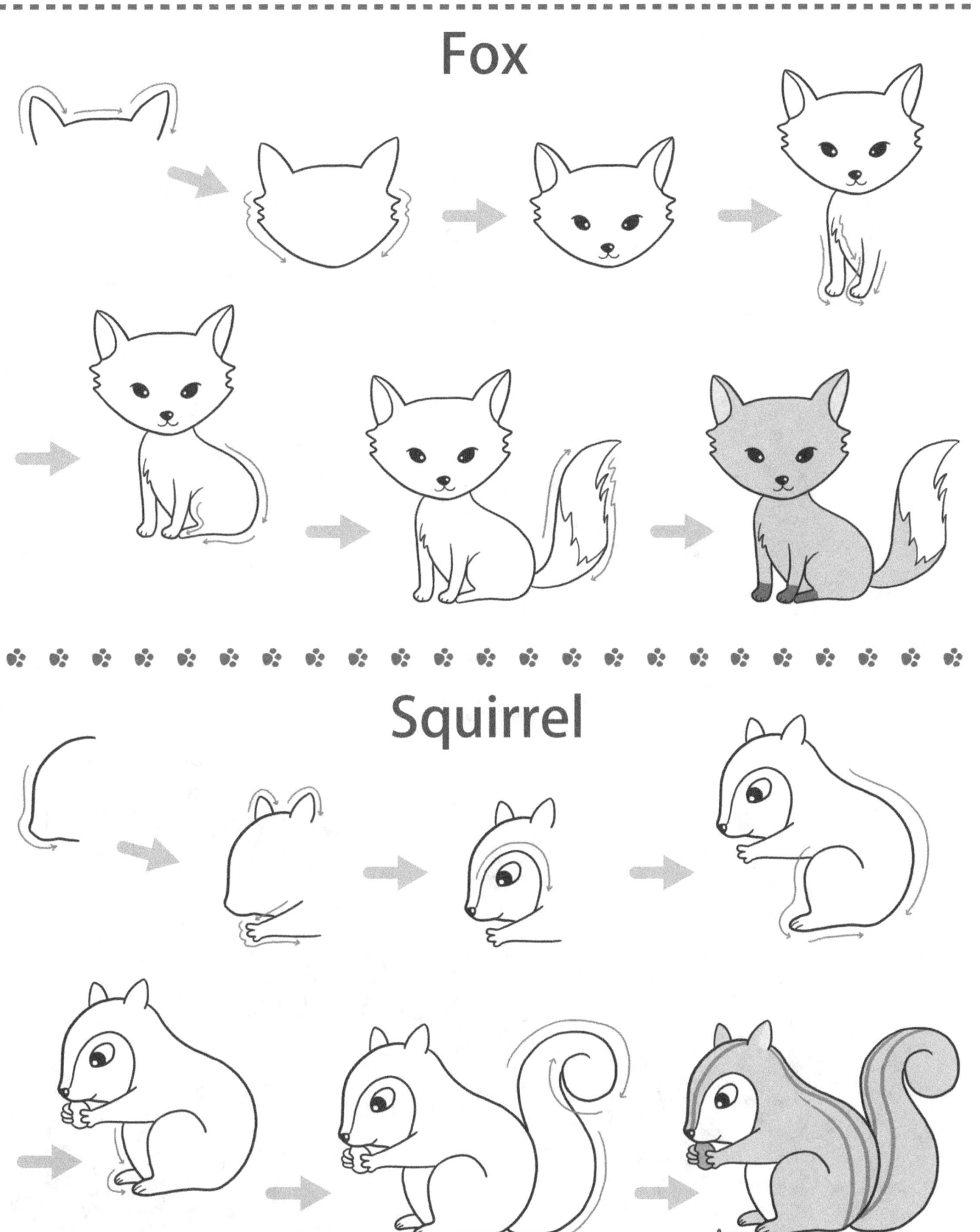

Mouse

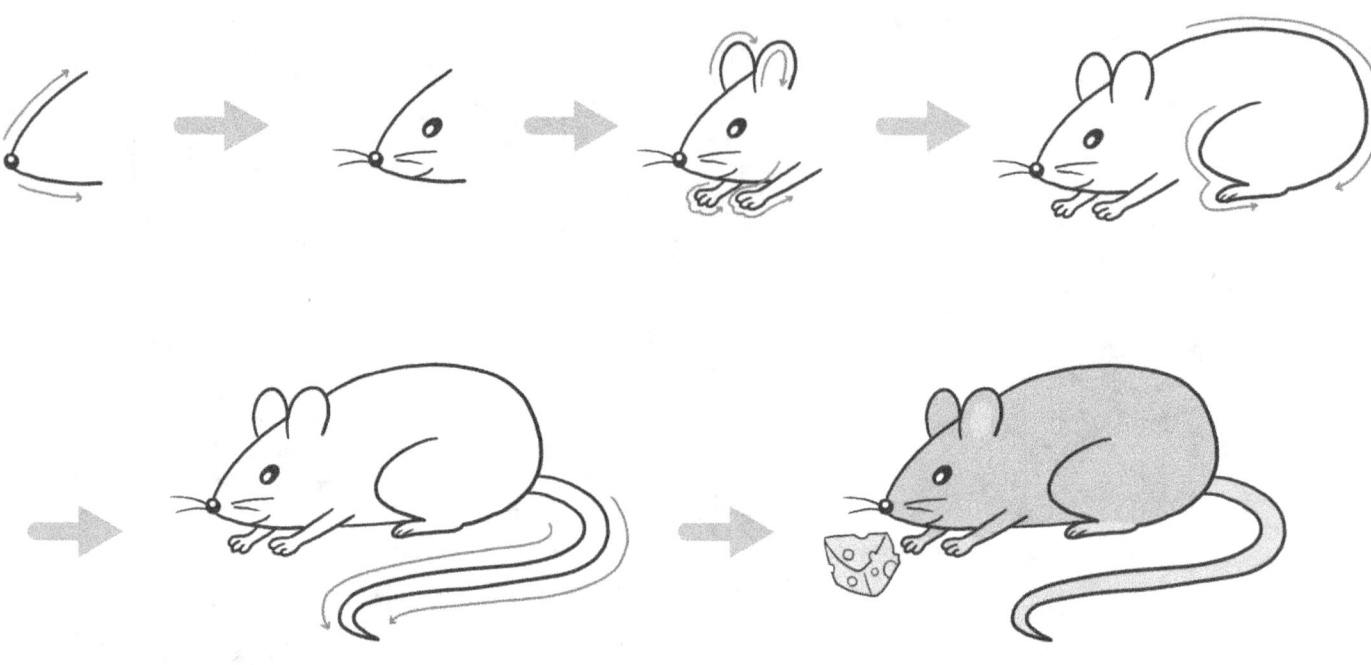

Bat

Raccoon

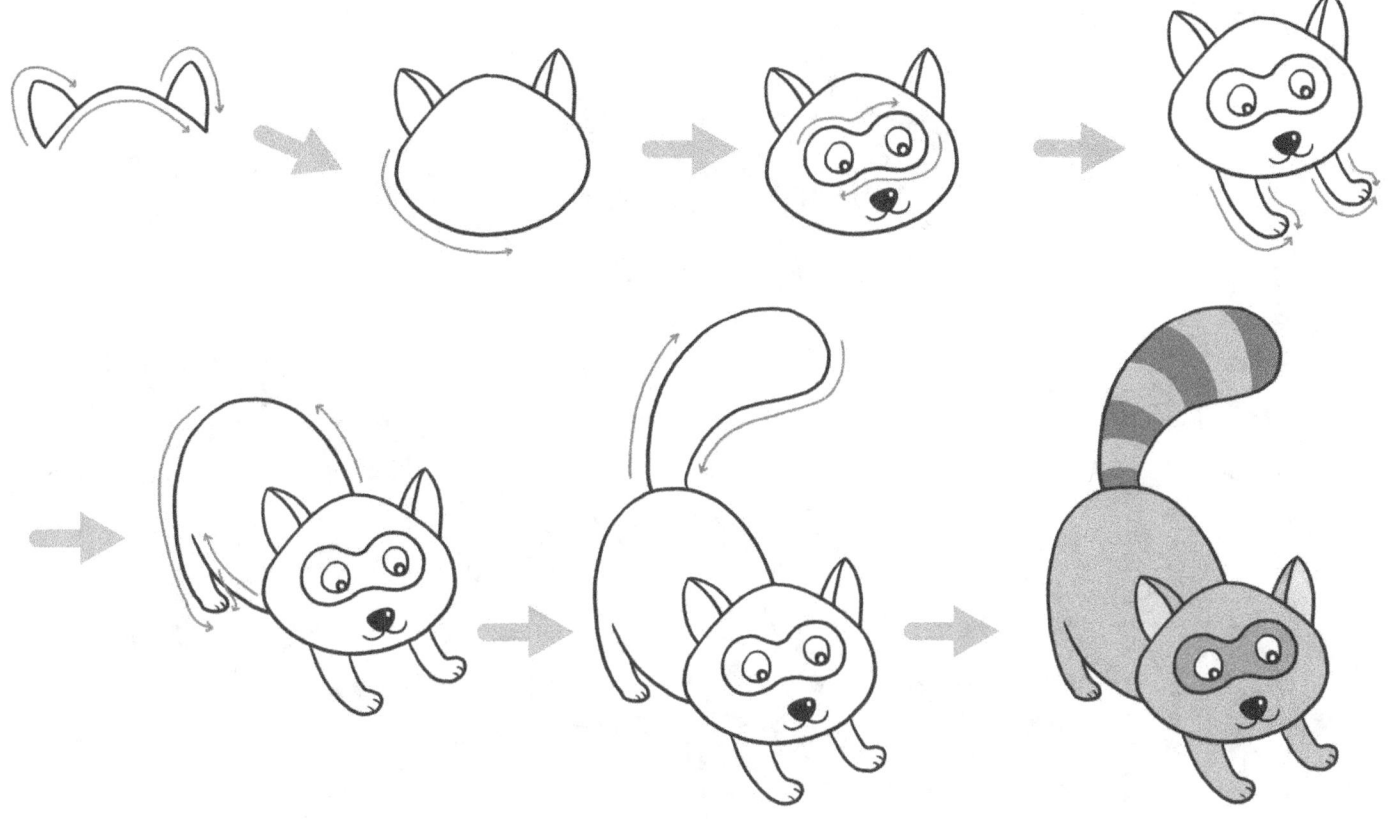

Skunk

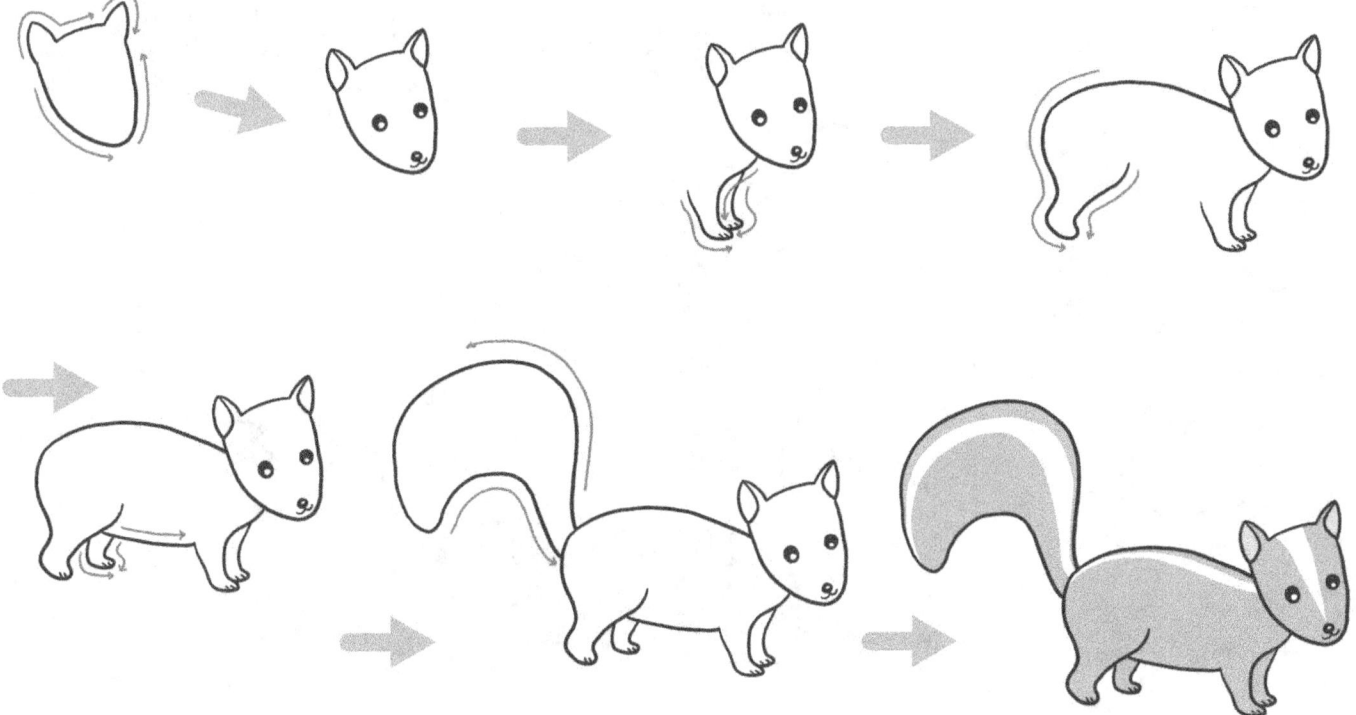

Sheep

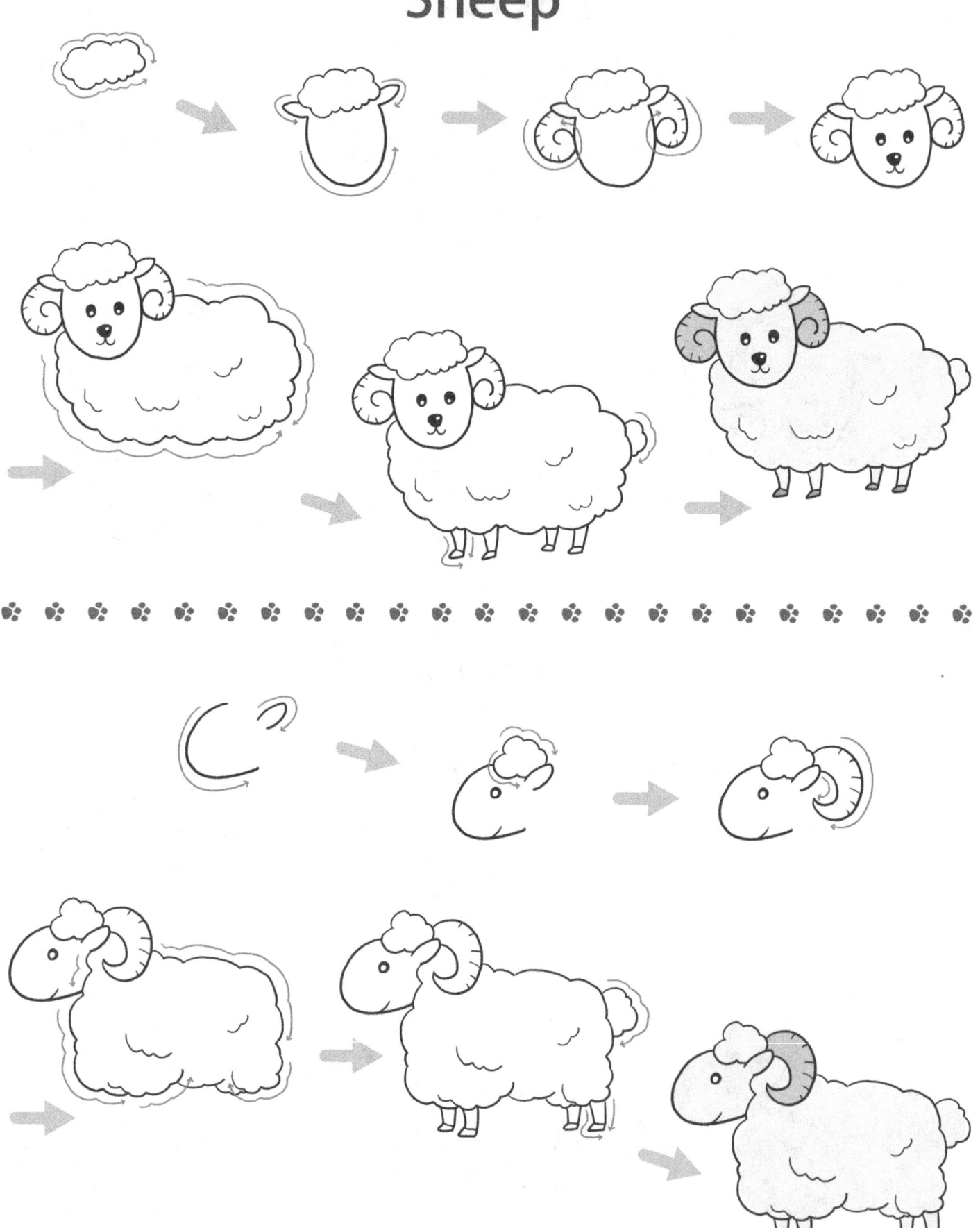

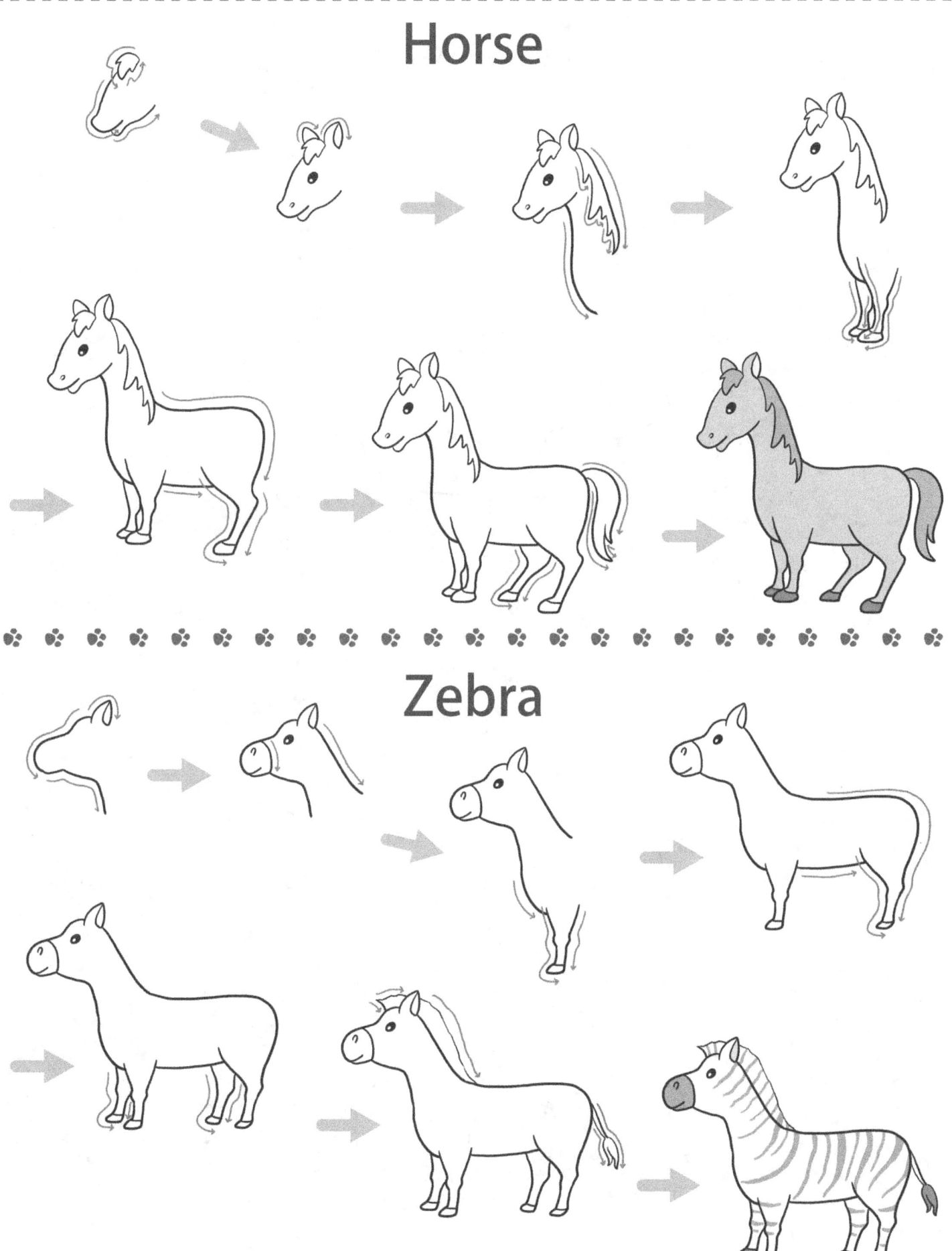

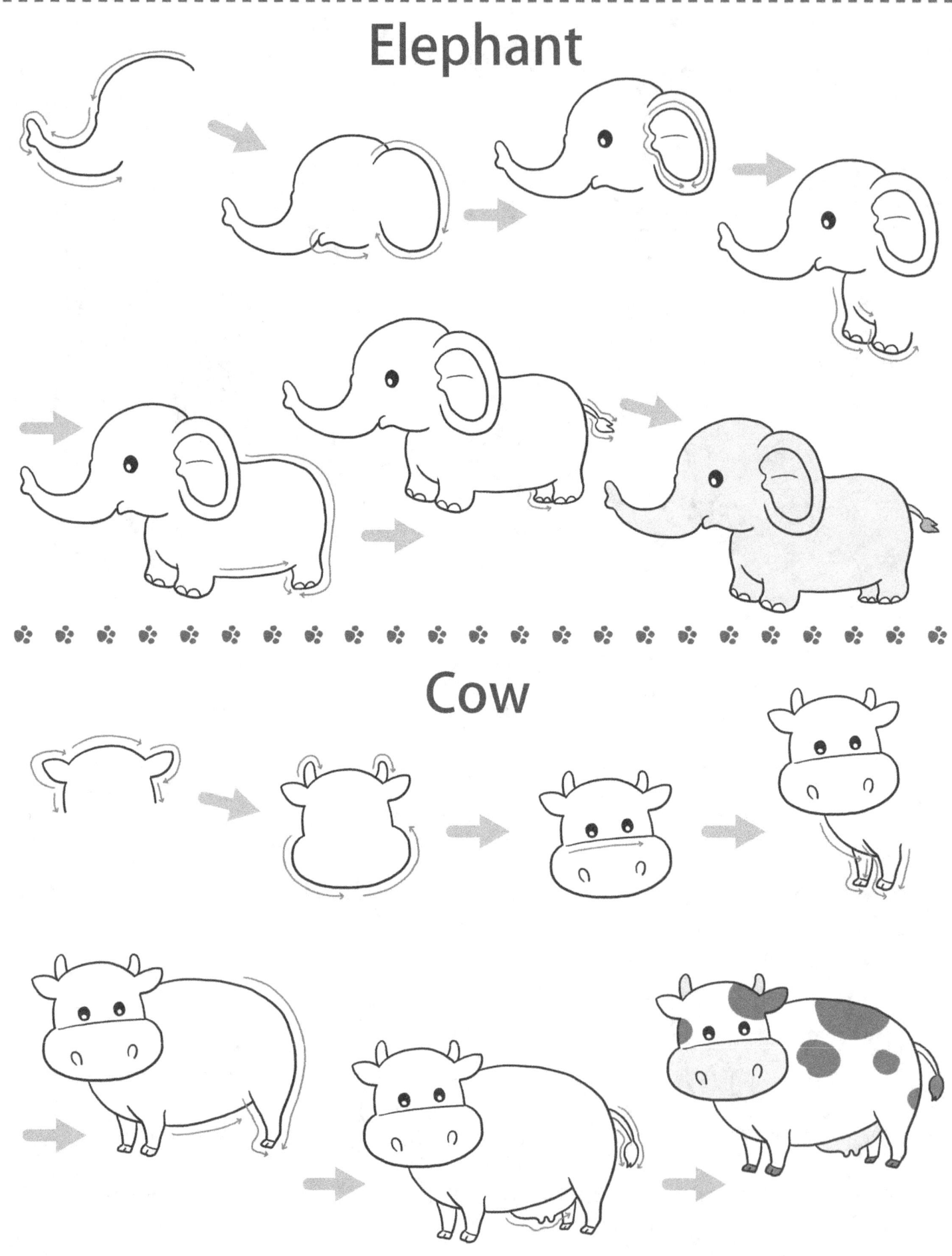

Monkey

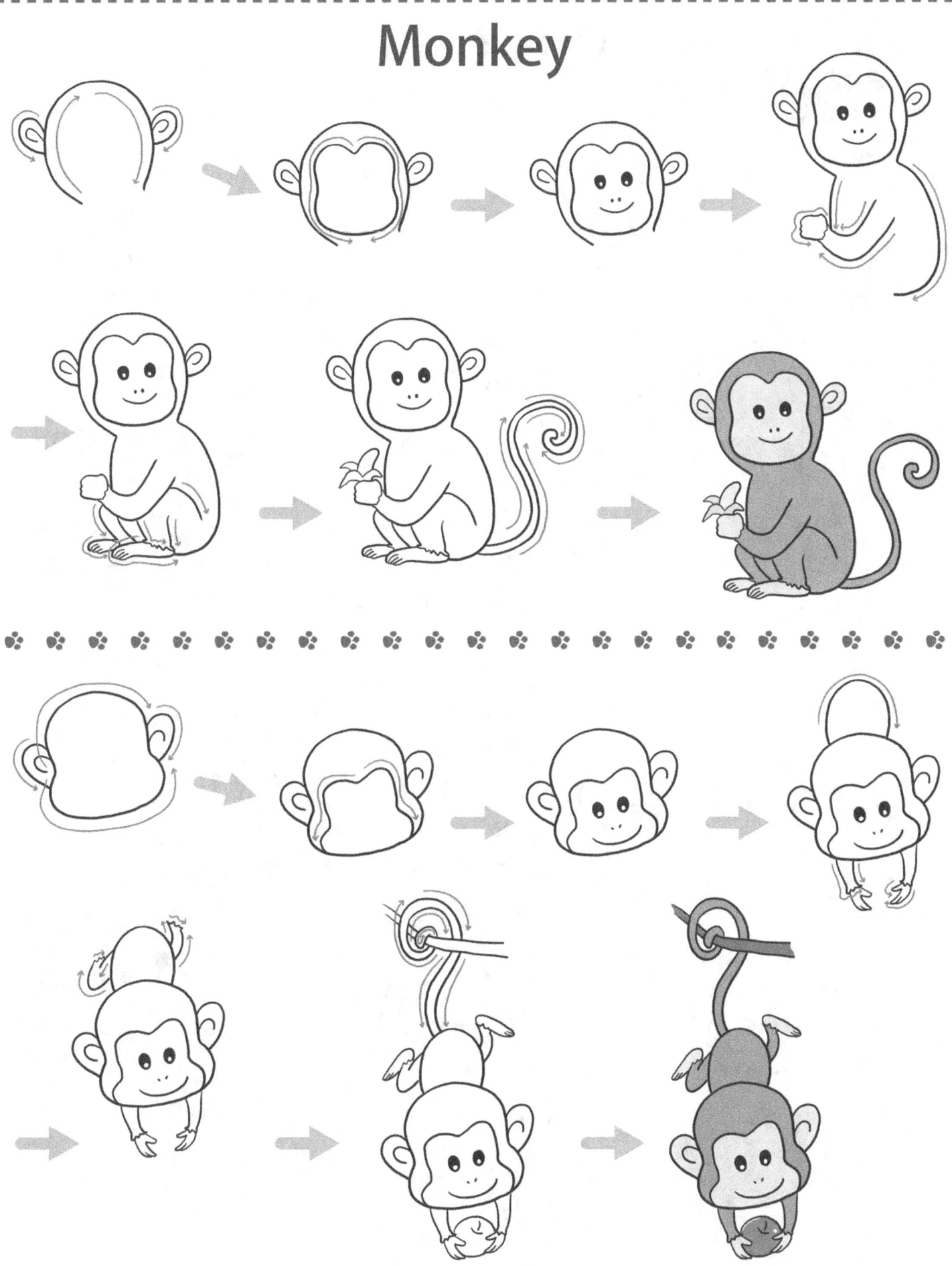

Orangutan

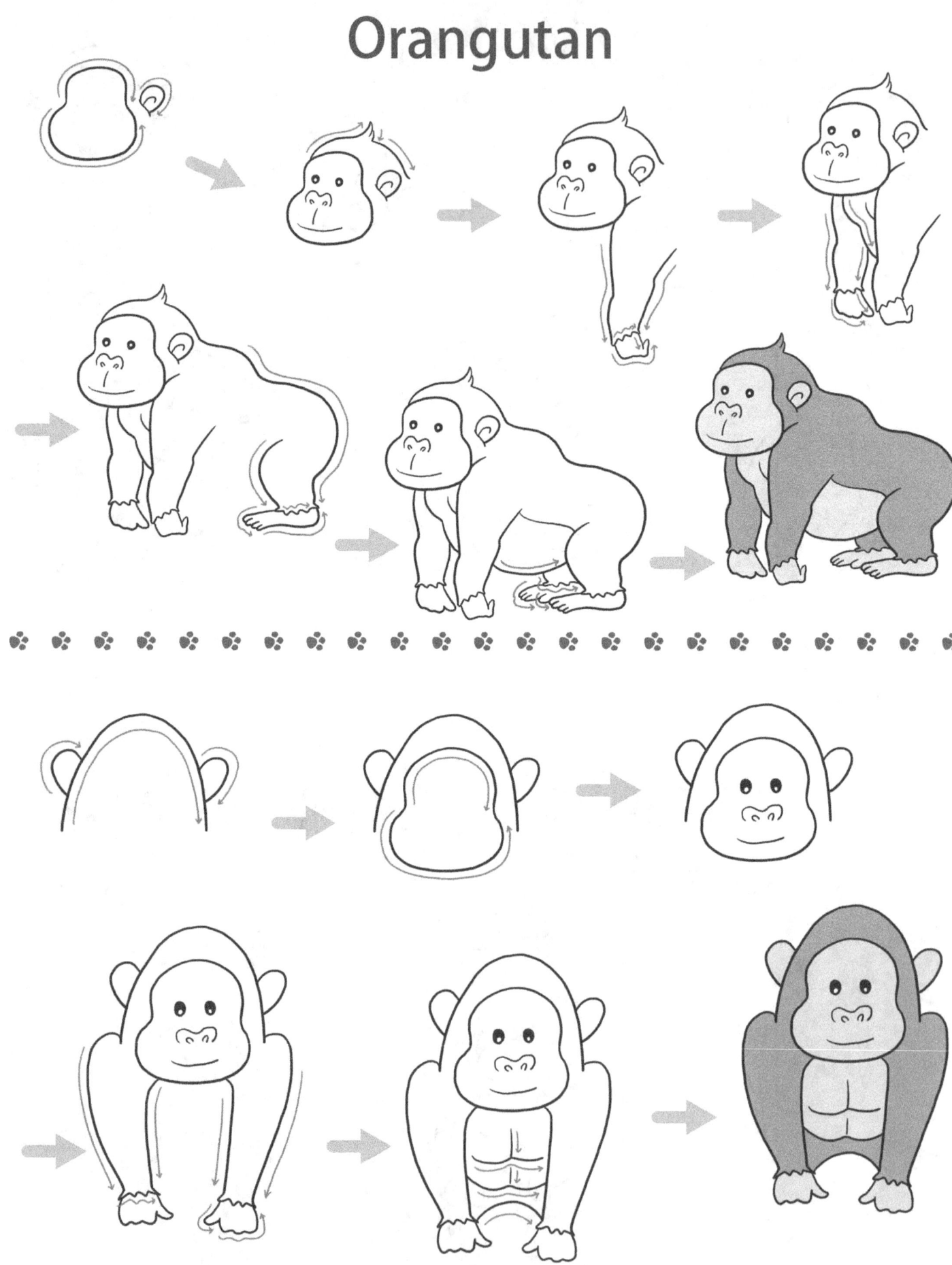

Deer

Giraffe

Alpaca

Camel

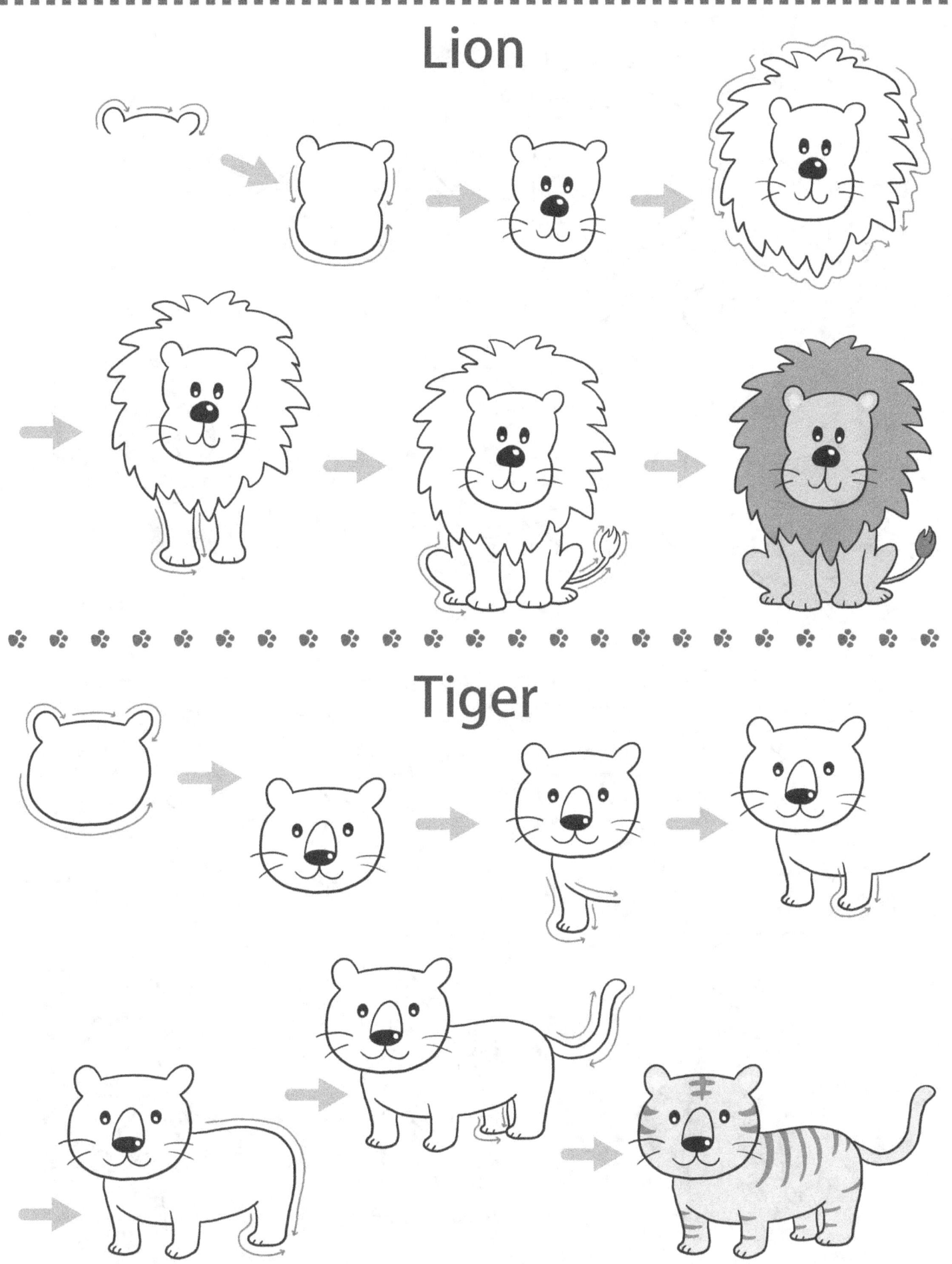

Bear

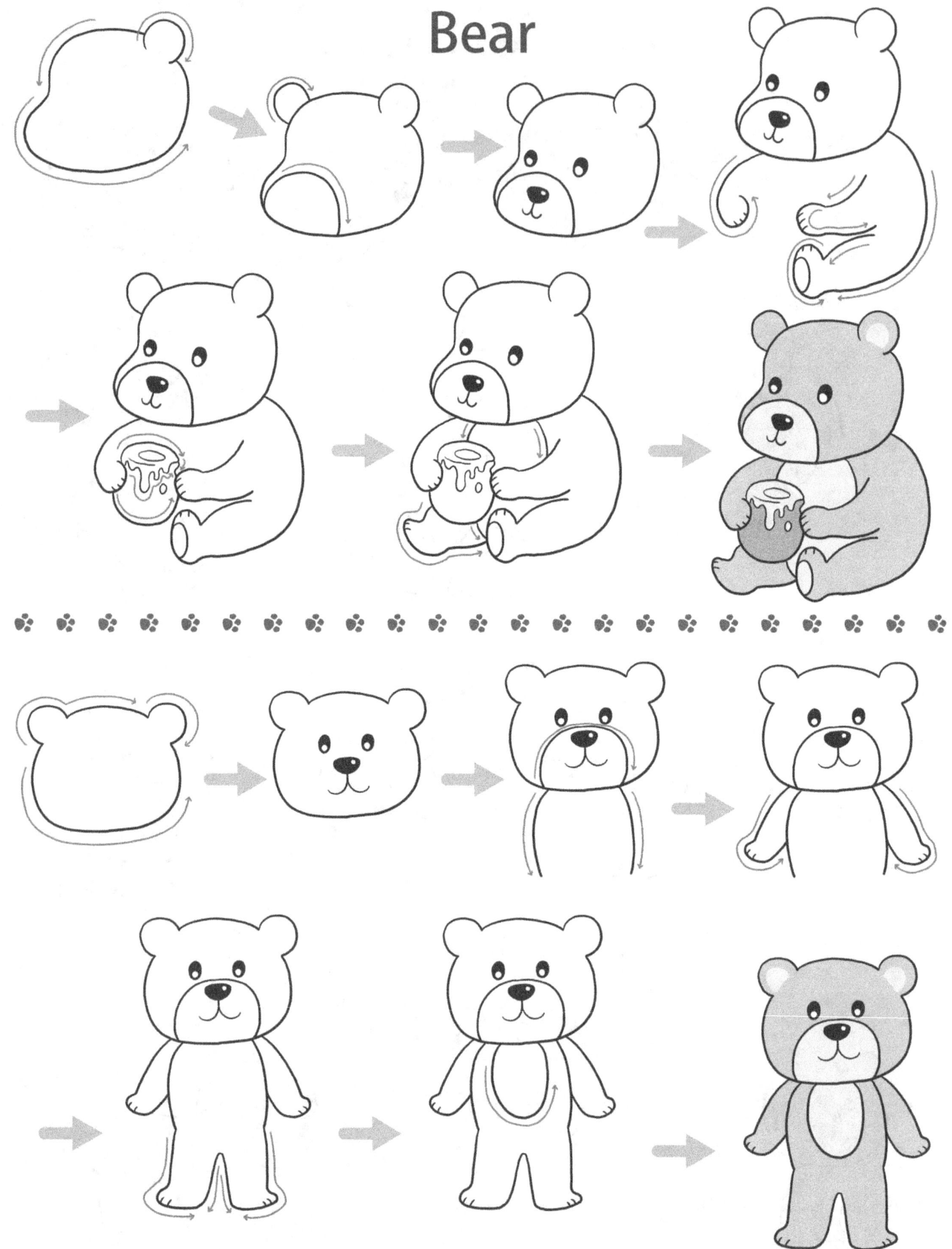

Panda

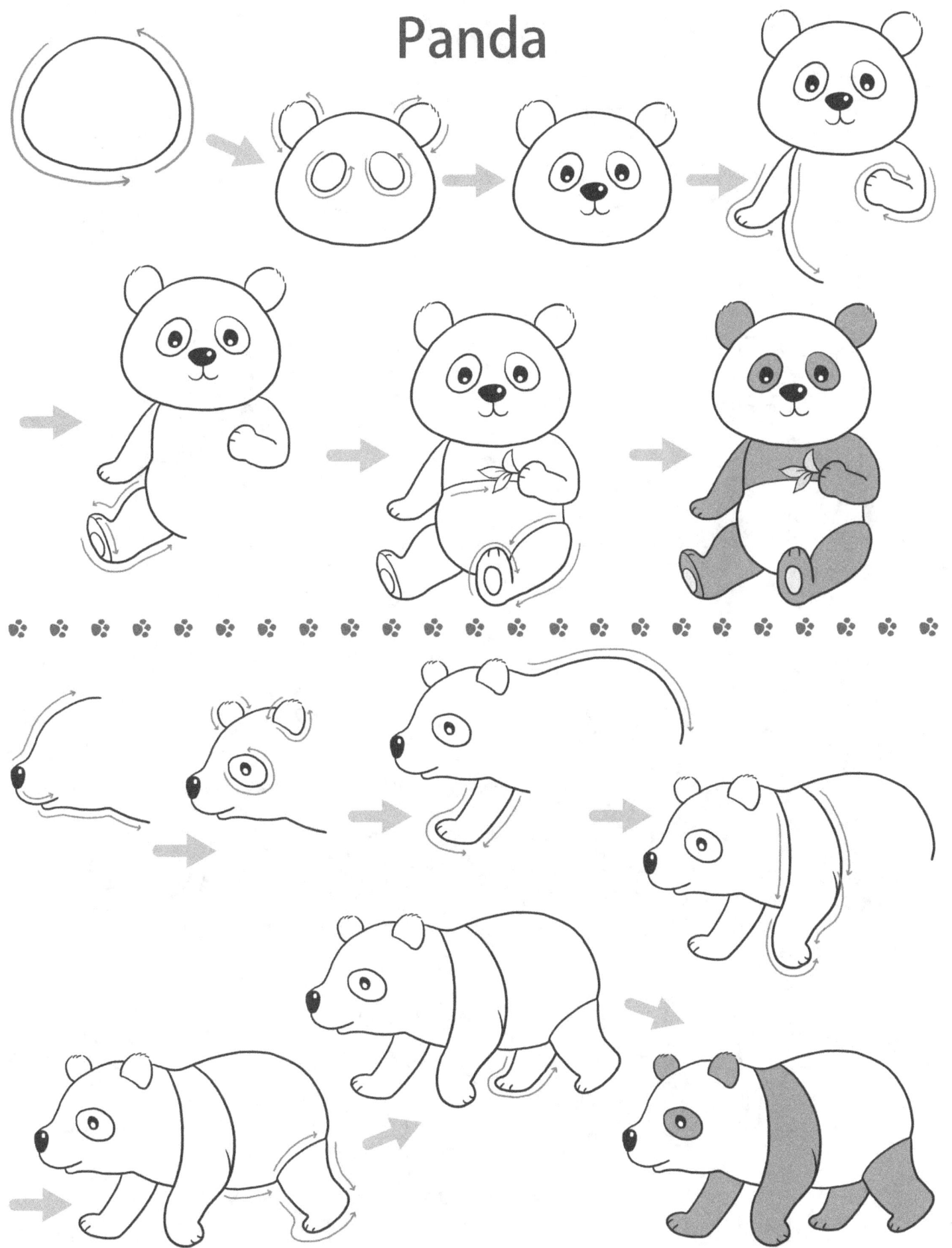

Wolf

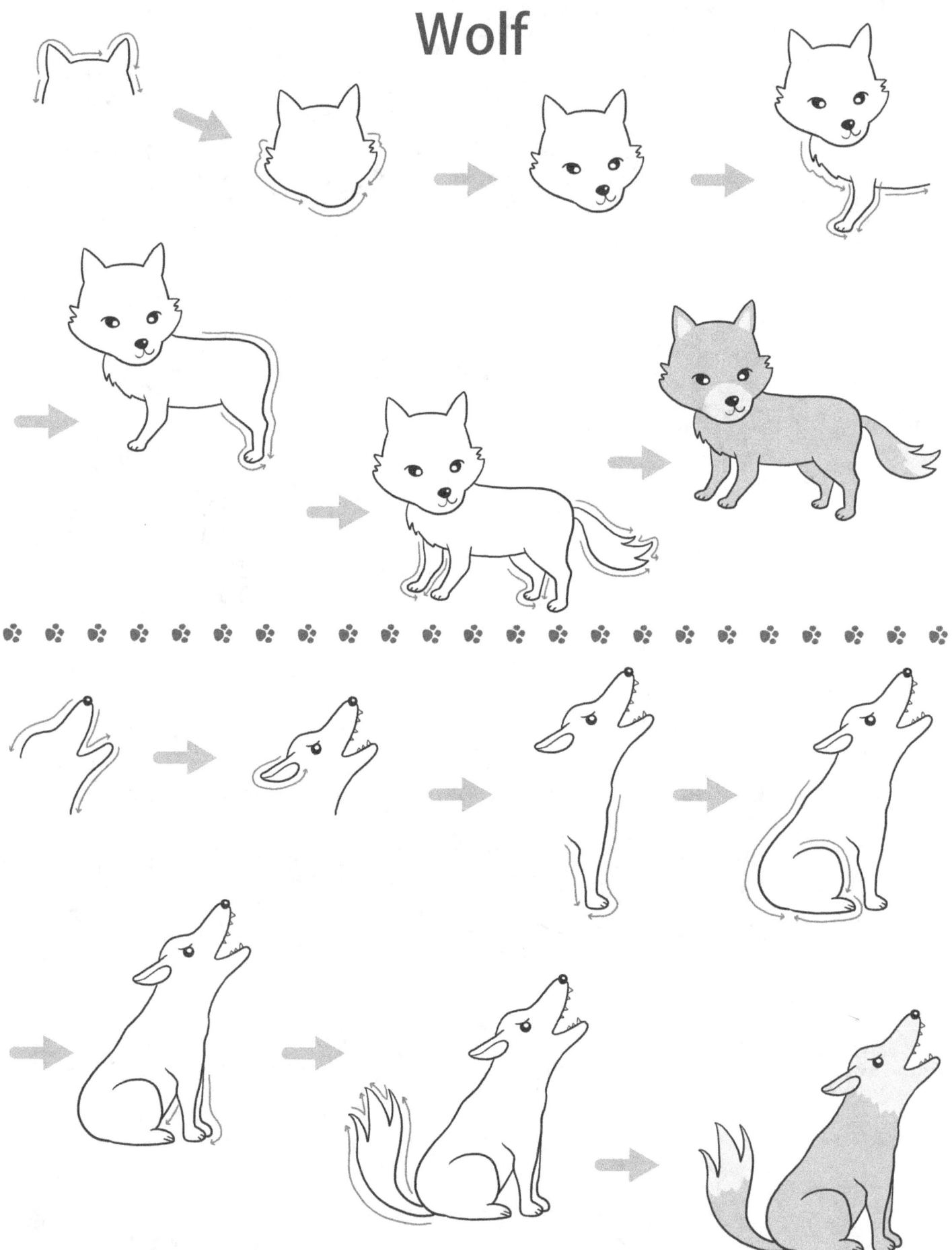

Leopard

Rhinoceros

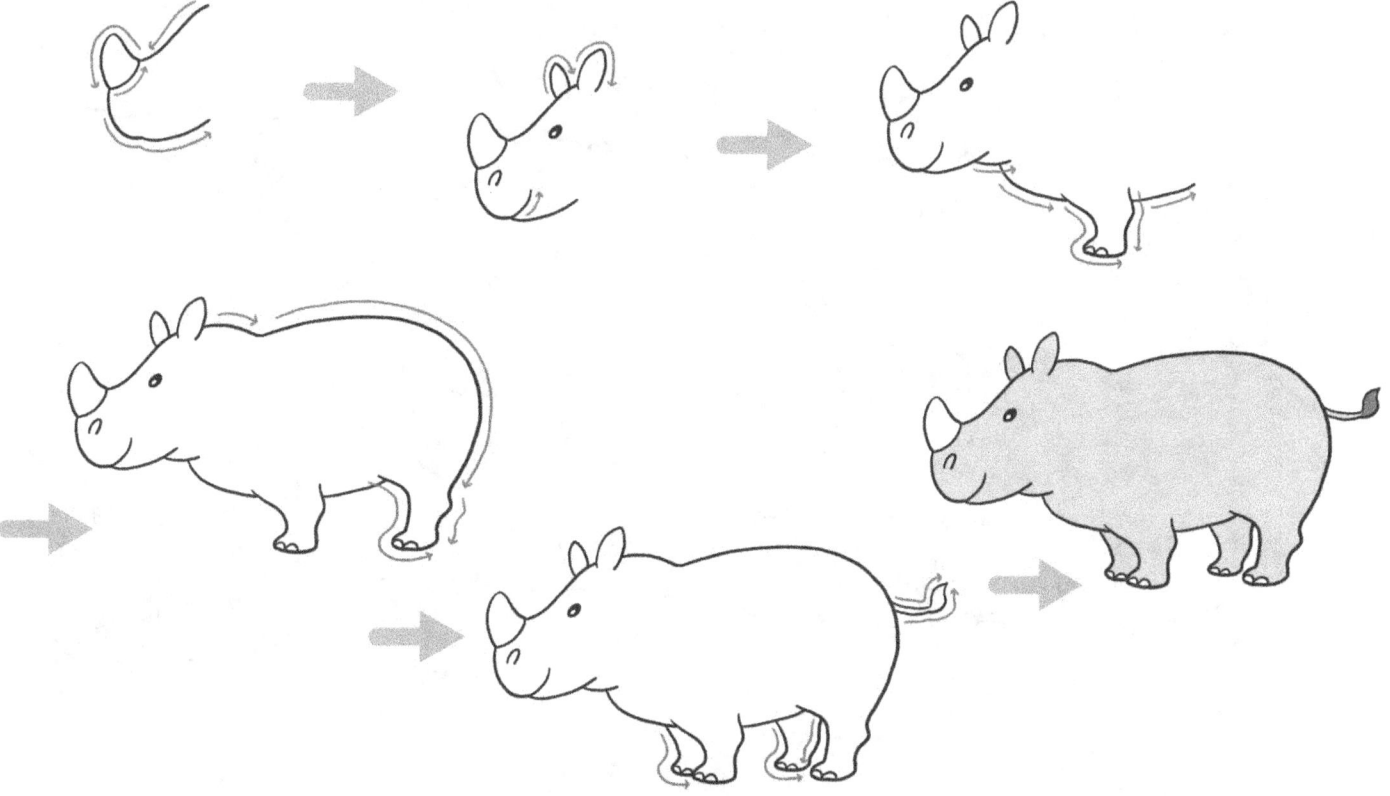

Hippo

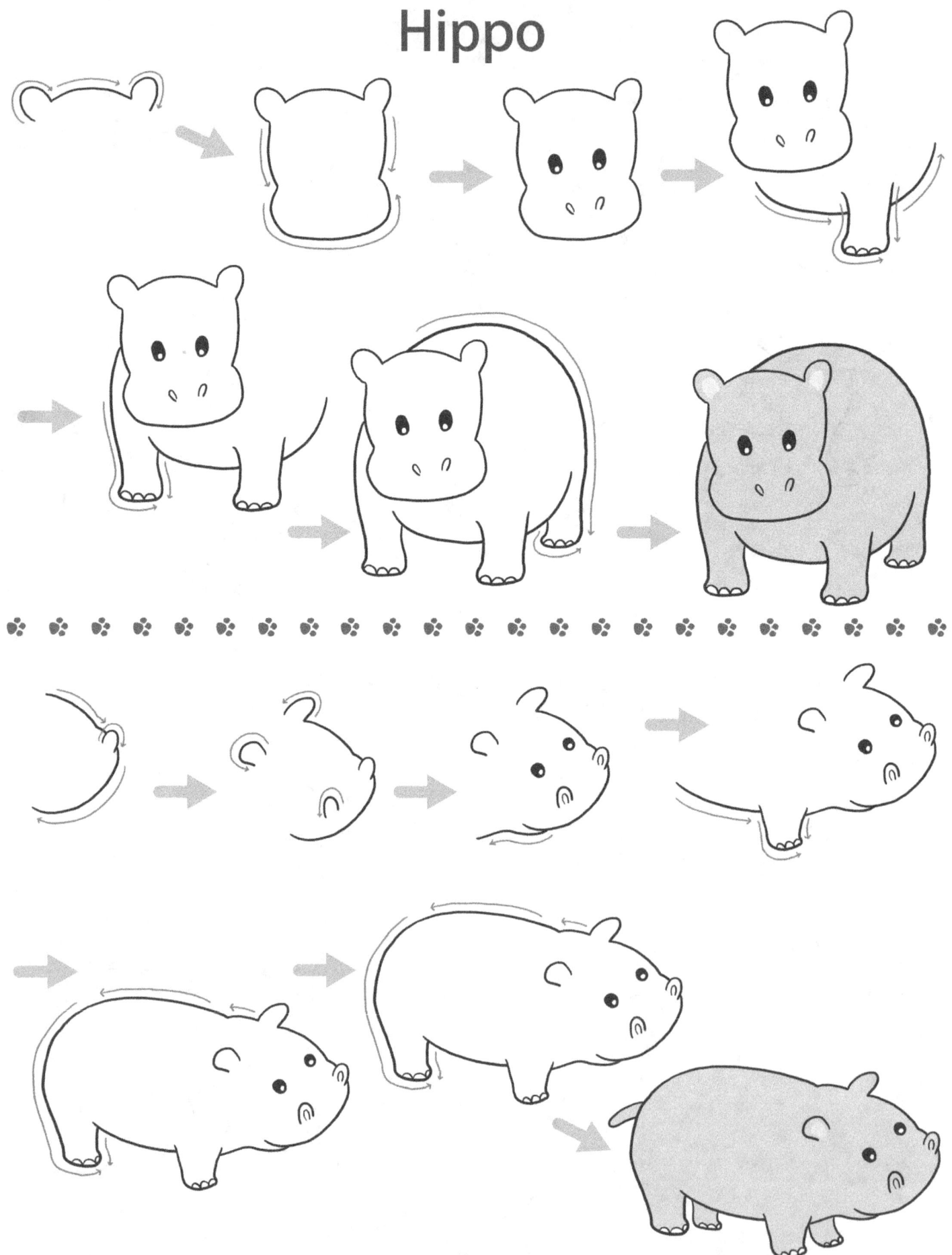

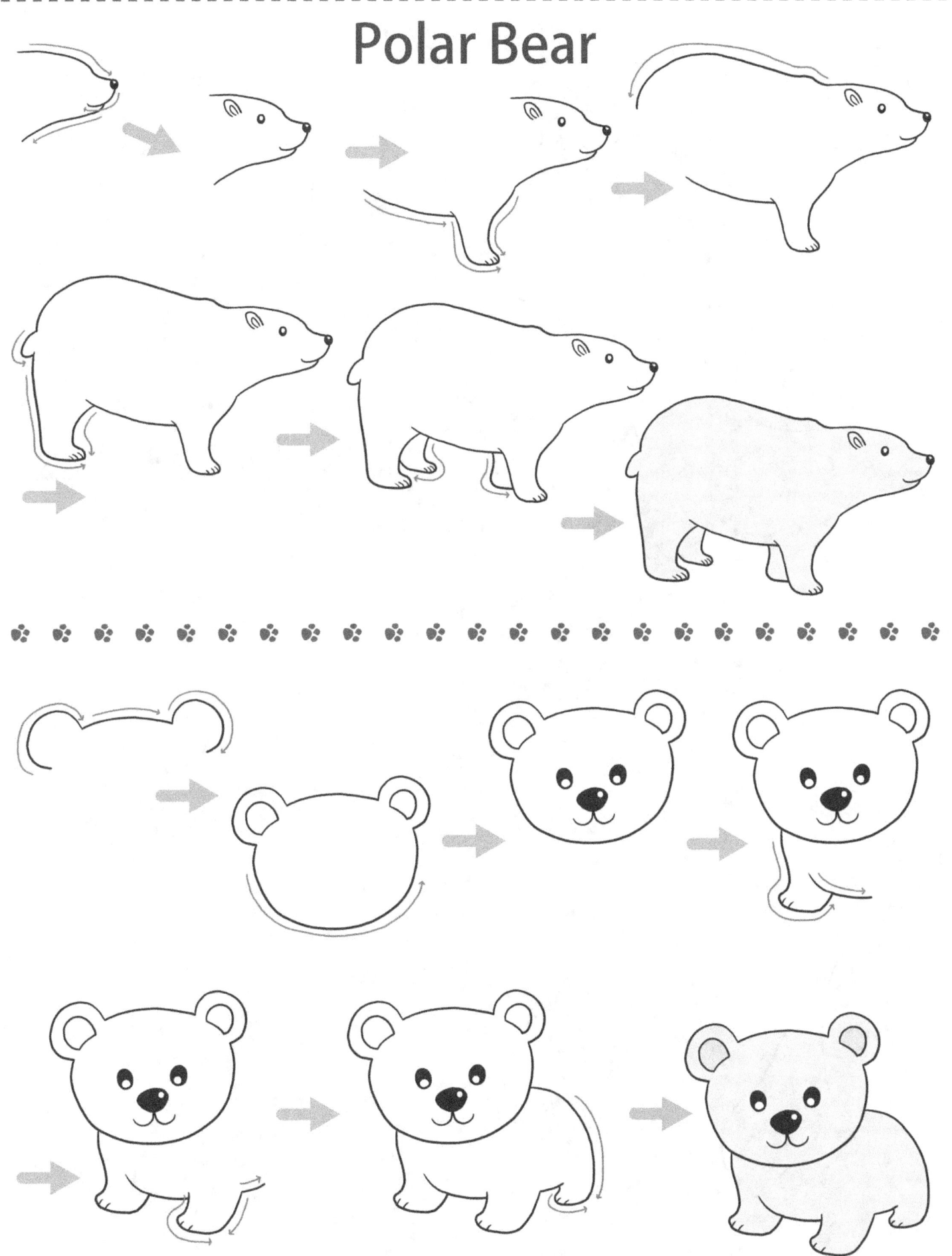

Koala

Kangaroo

Sloth

Hedgehog

Anteater

malayan tapir

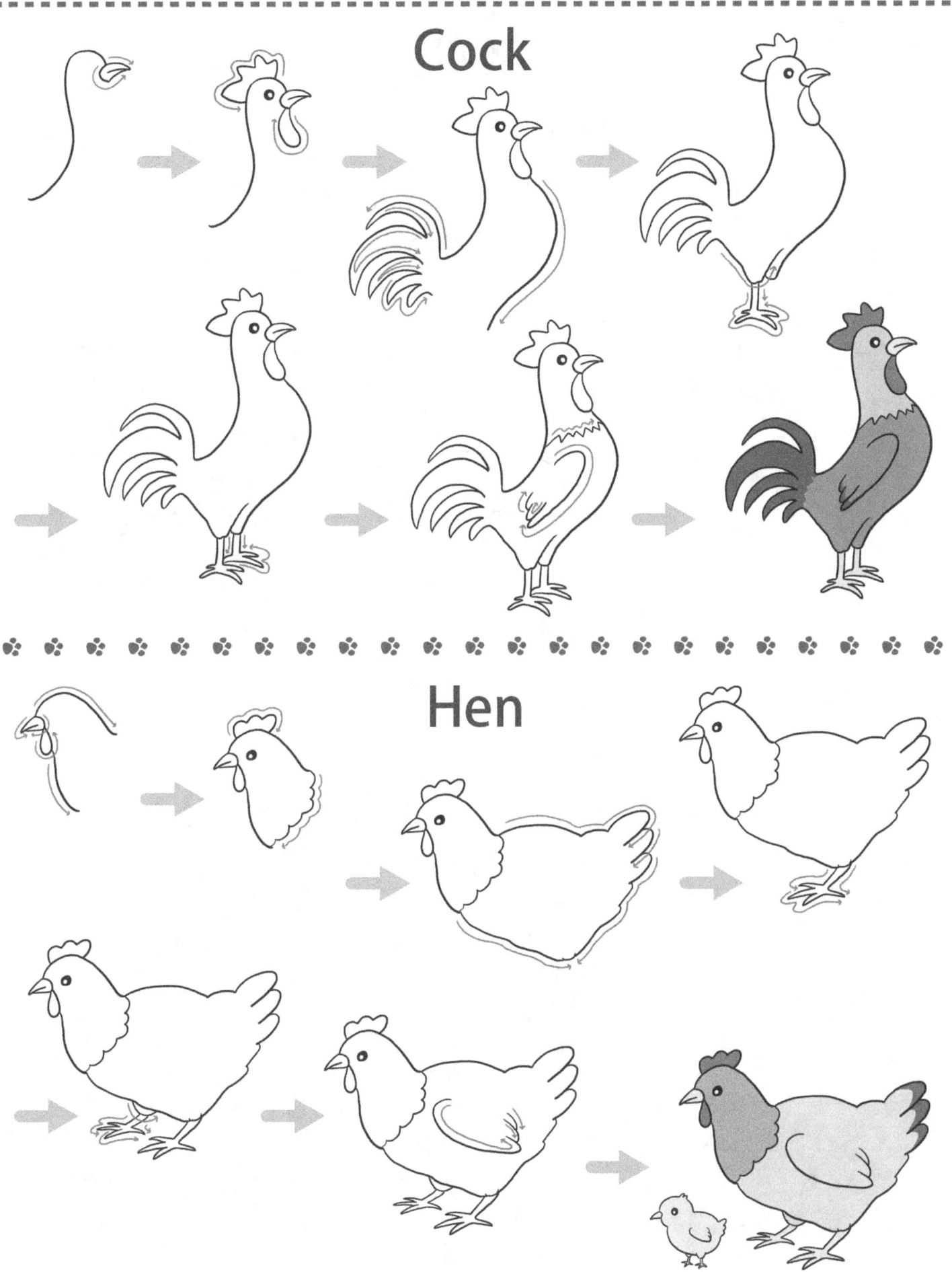

Duck

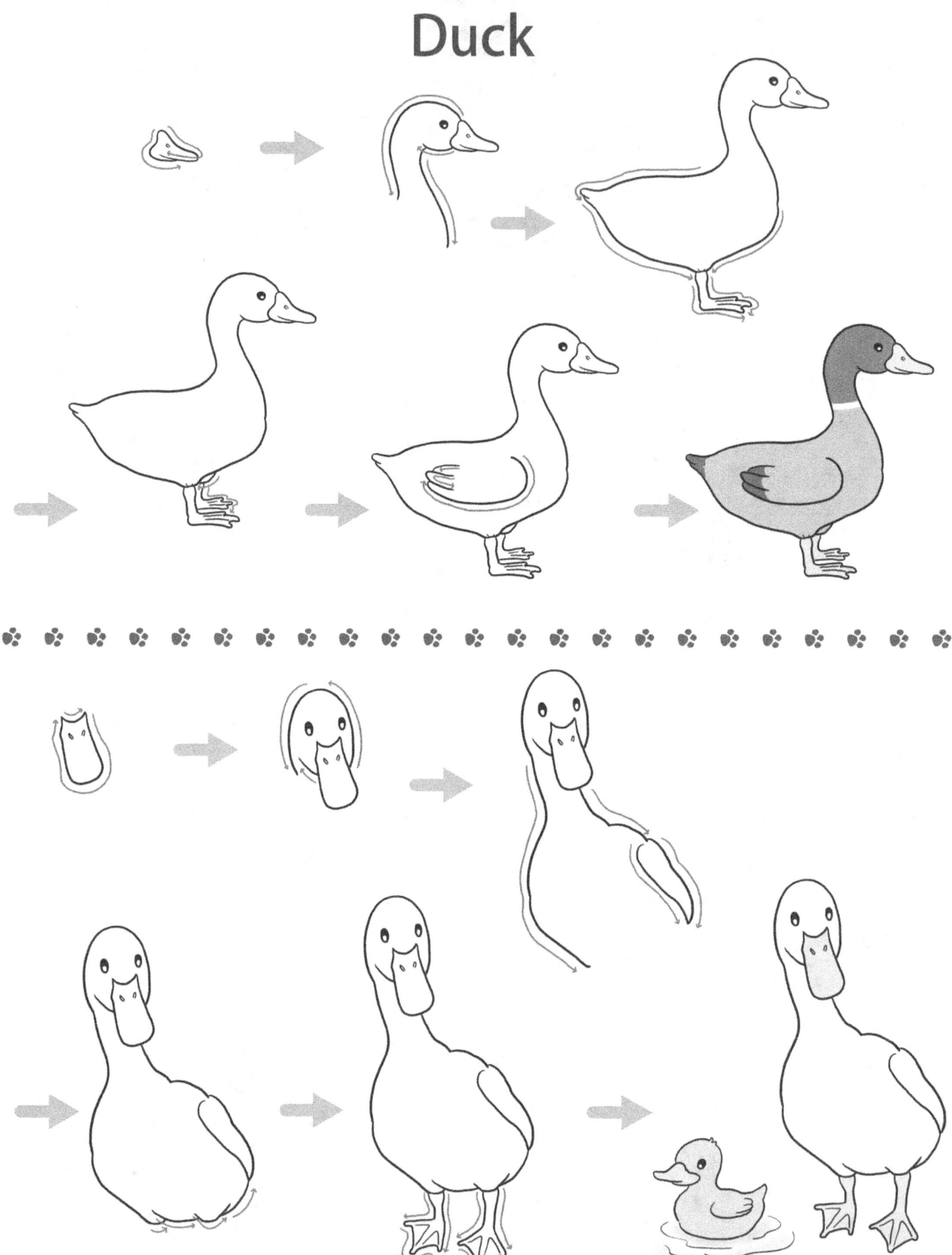

Swan

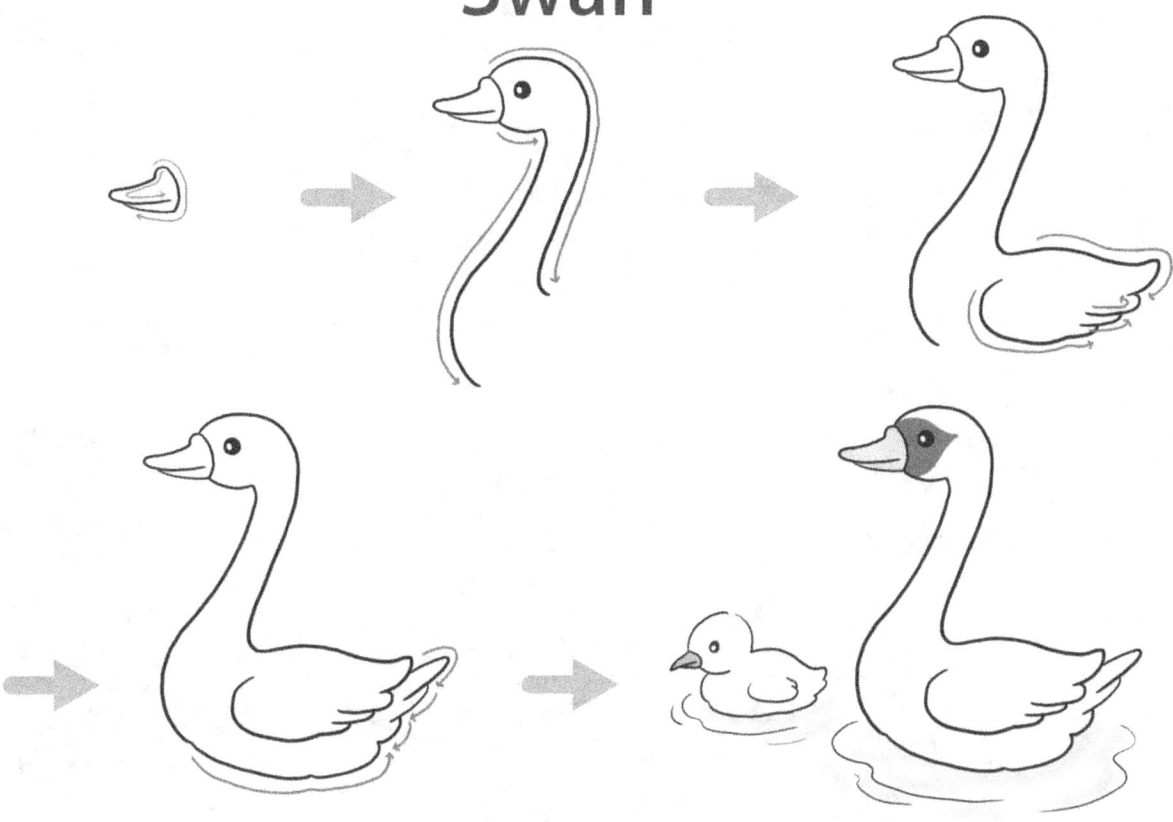

Stork

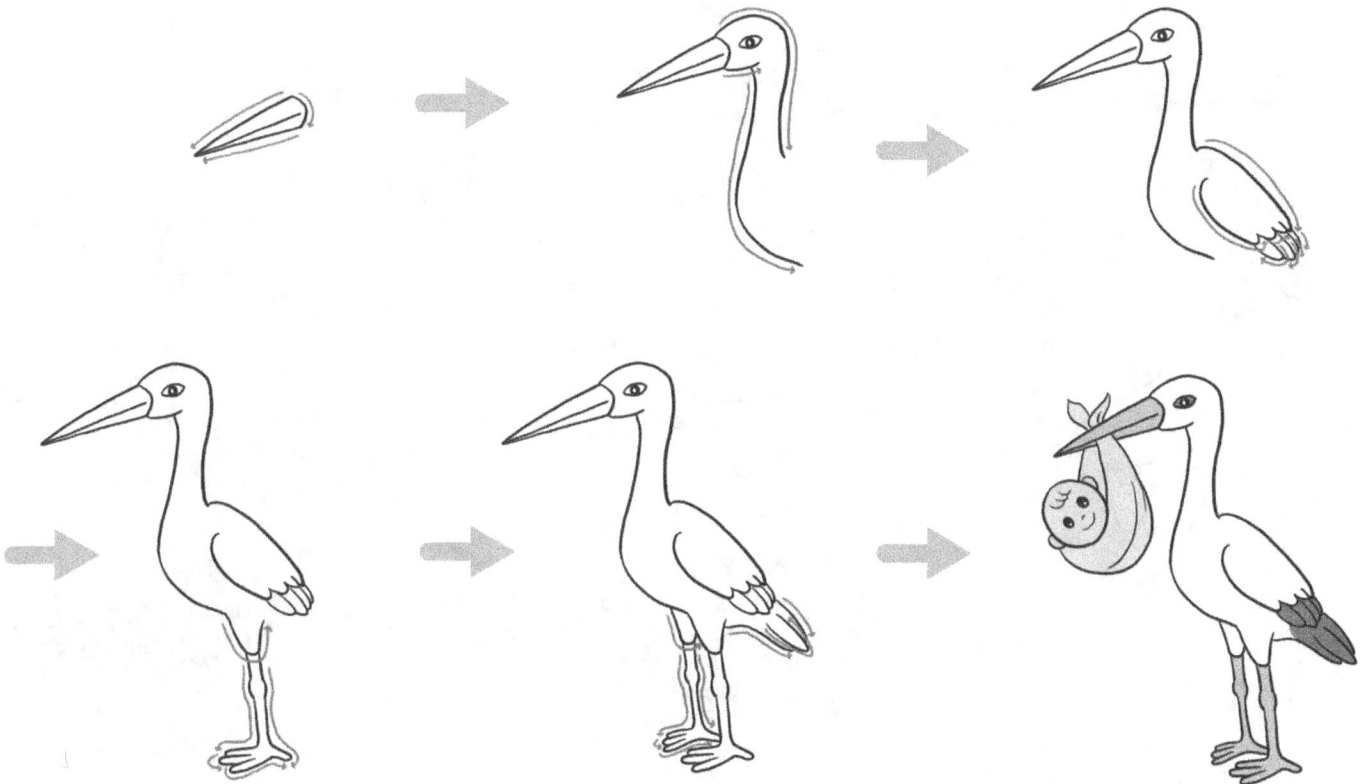

Owl

Crow

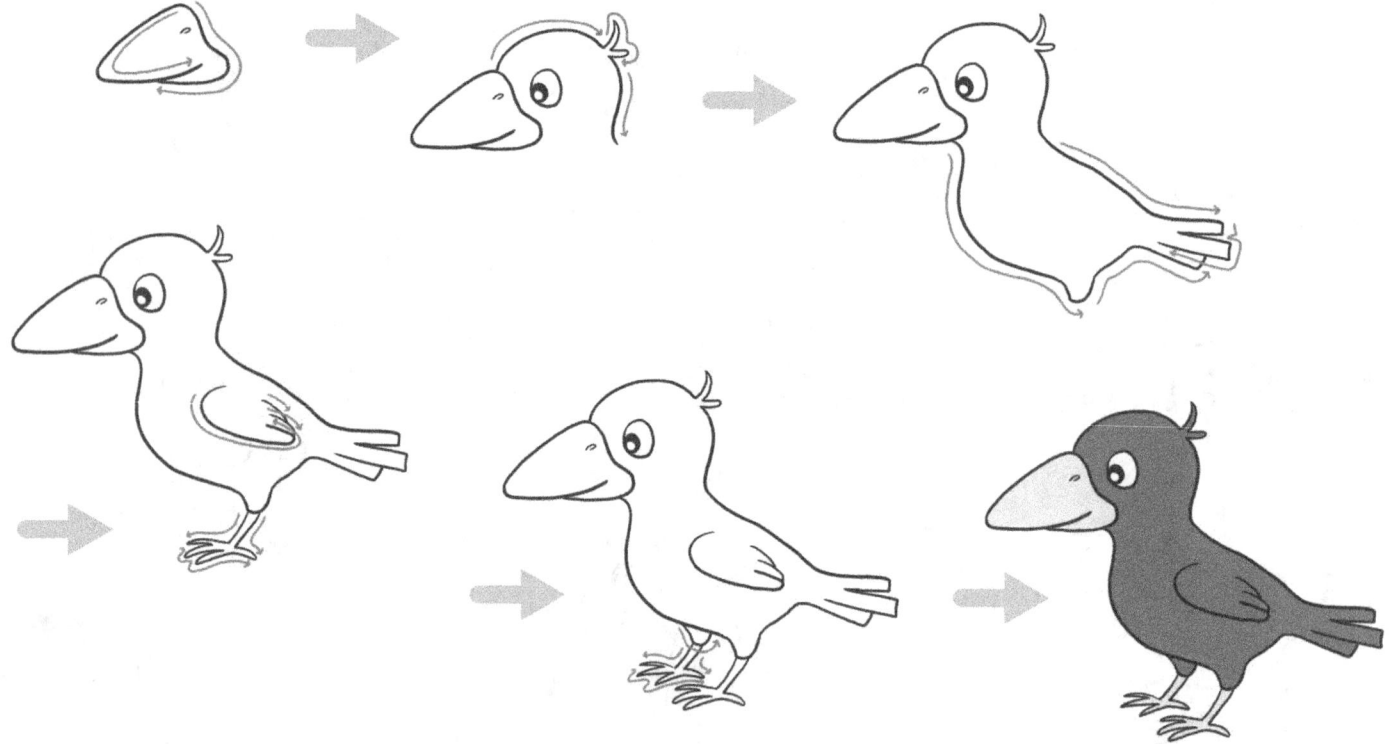

Penguin

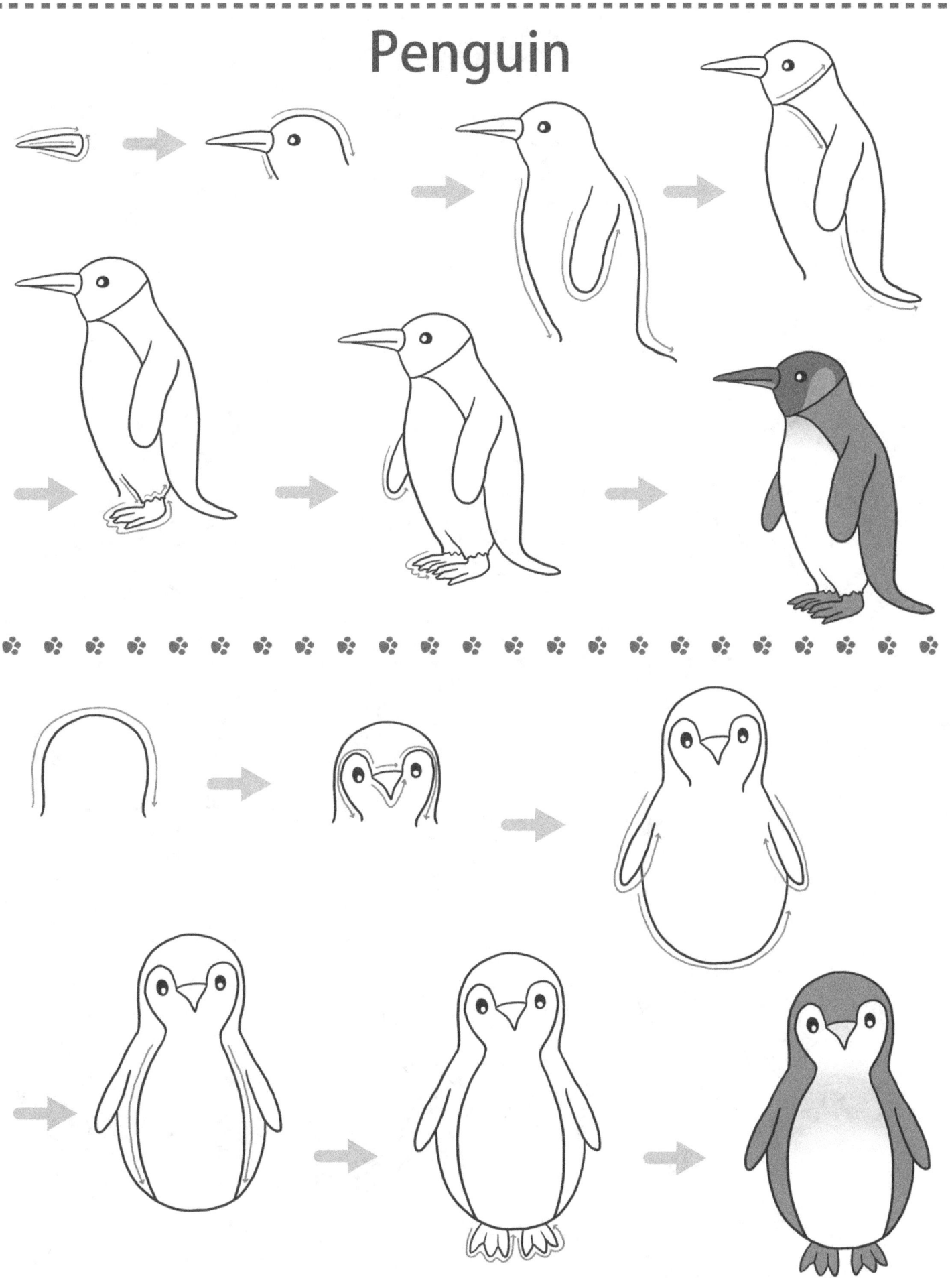

Pigeon

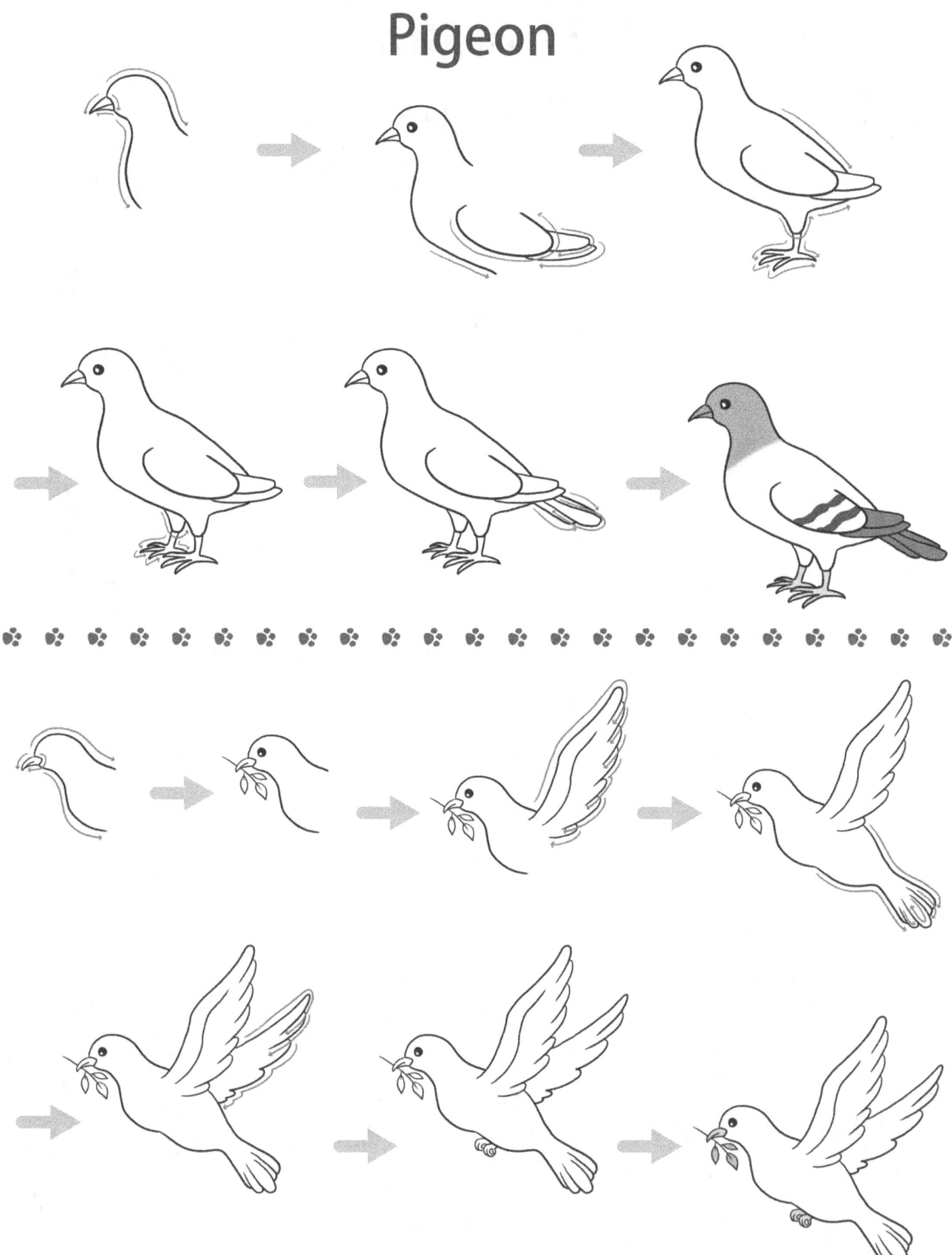

Parrot

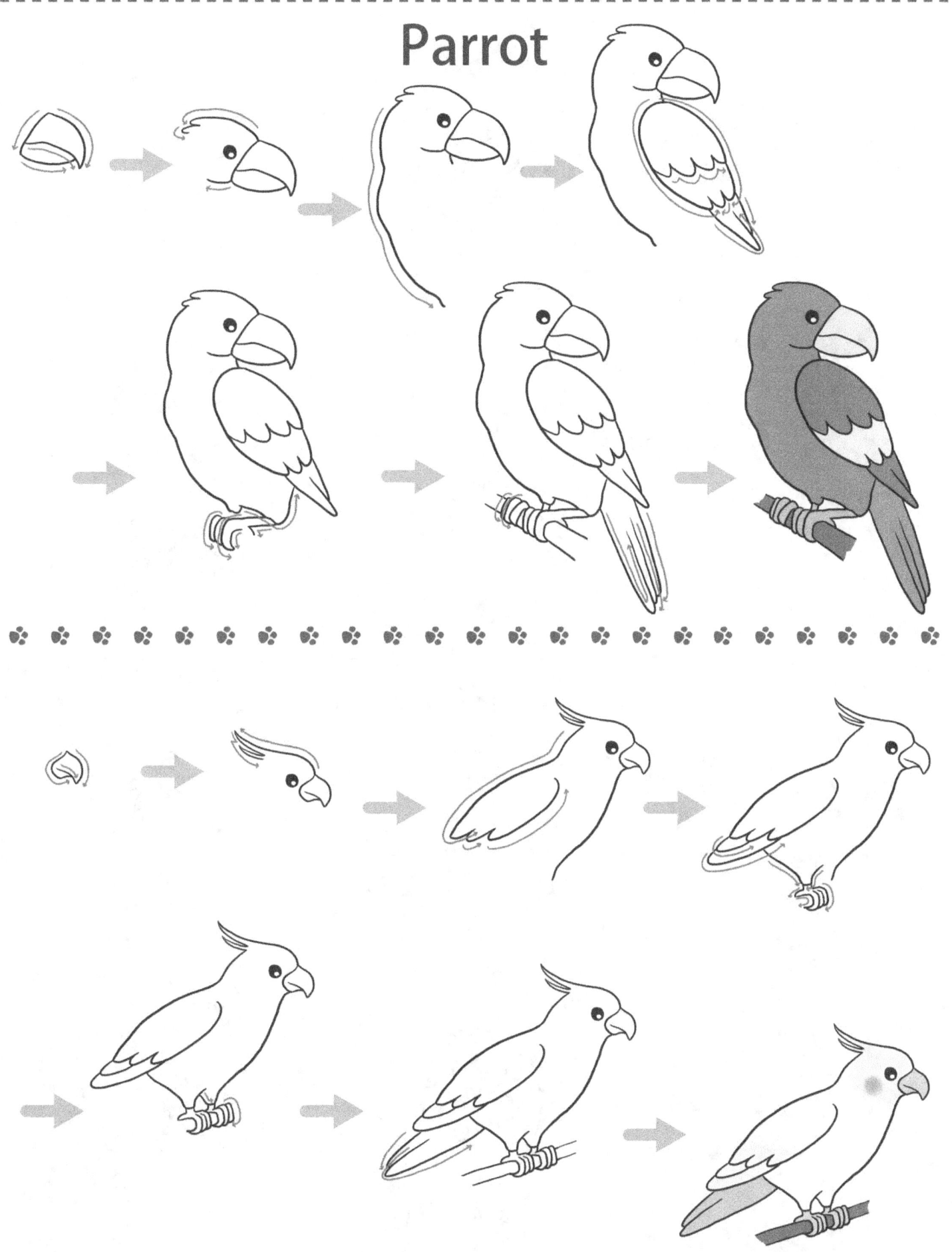

Eagle

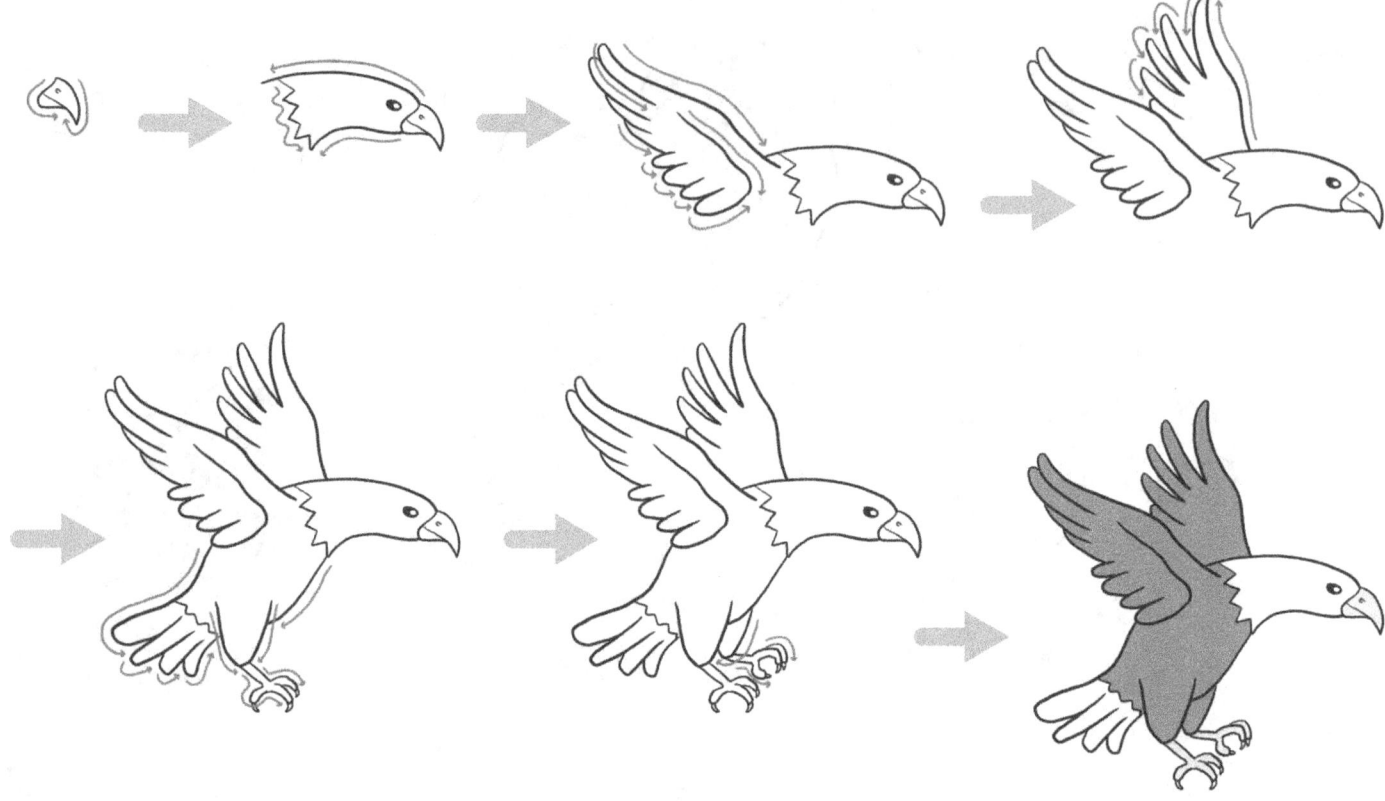

Vulture

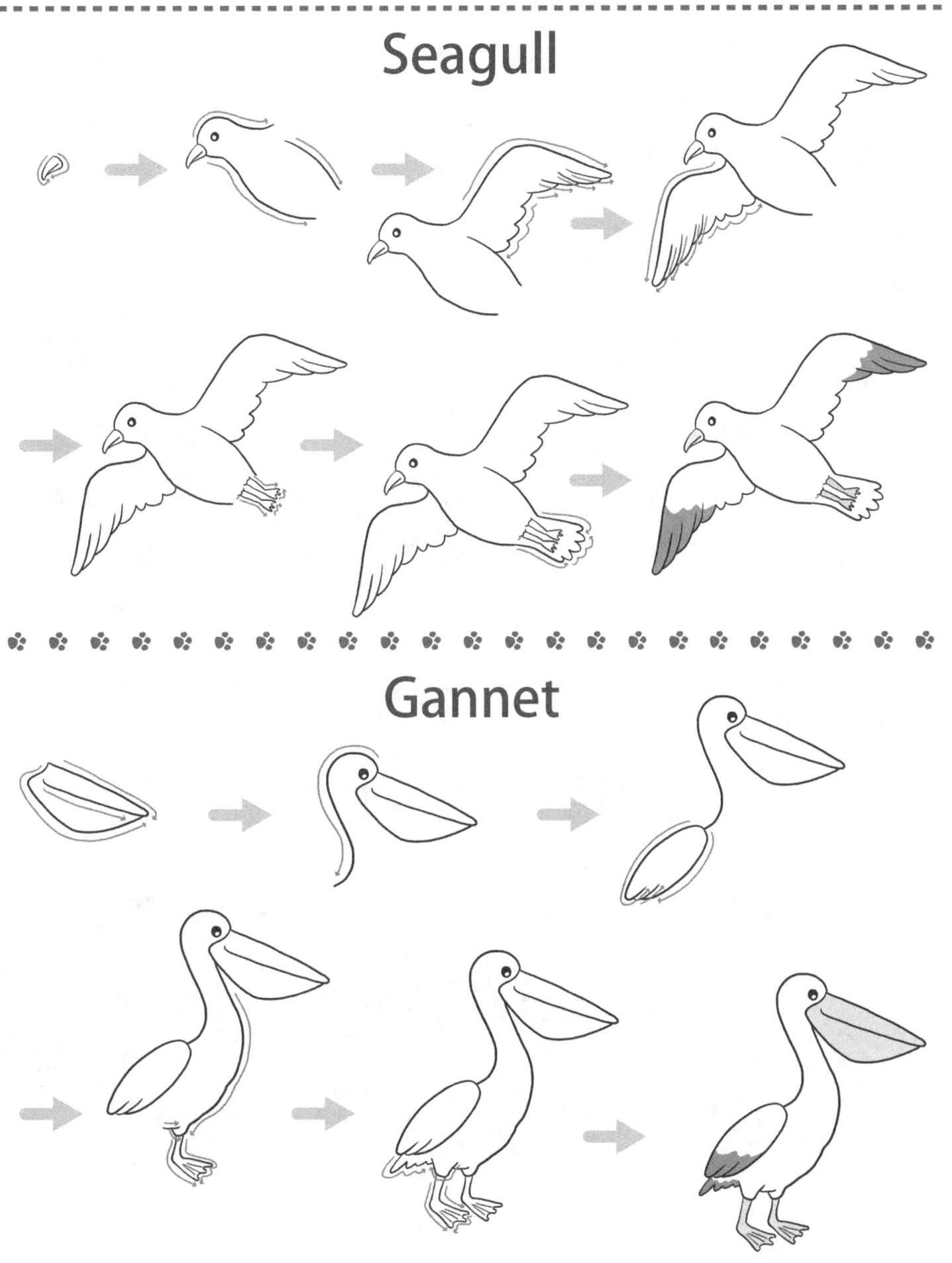

Ostrich

Peacock

Crocodile

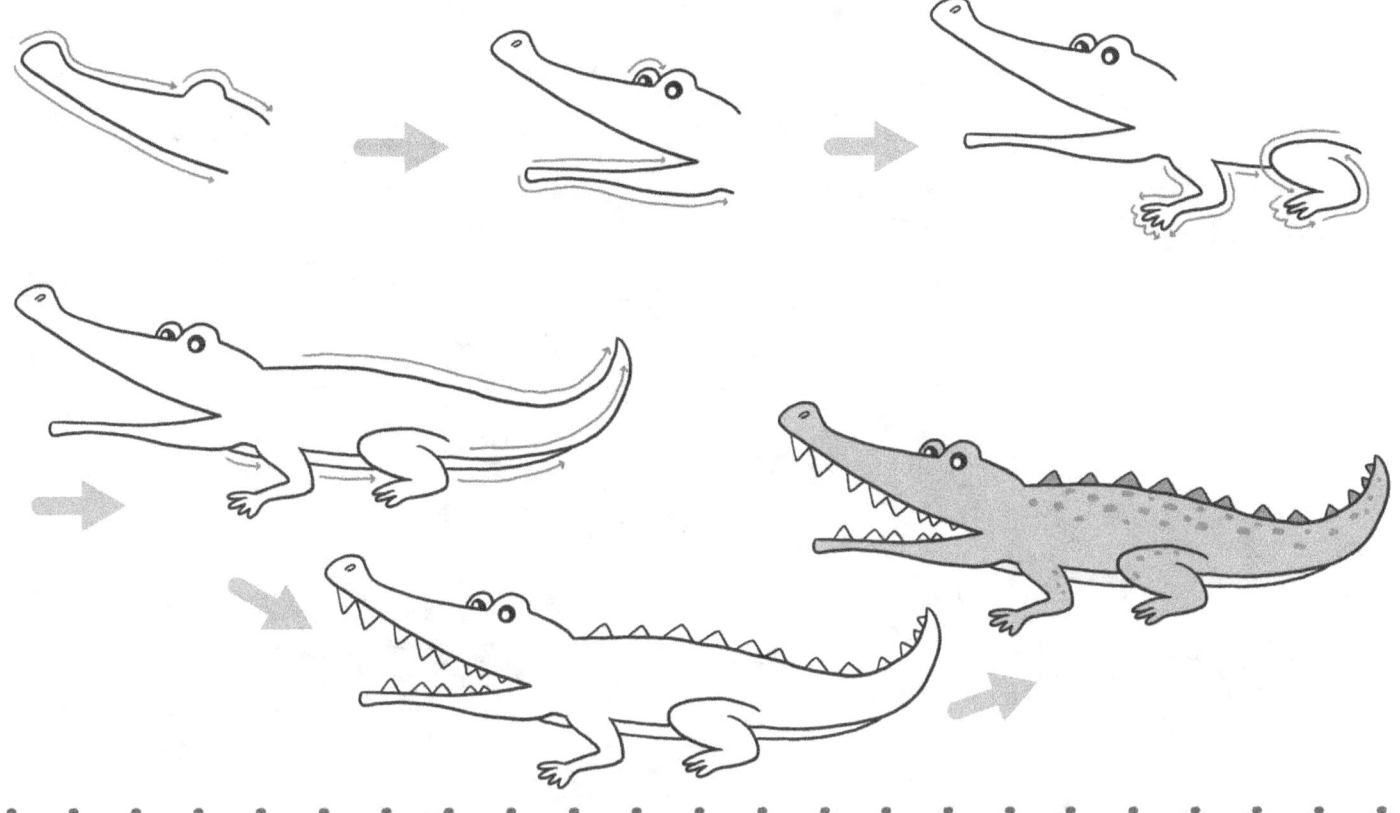

Snake

Turtle

Lizard

Frog

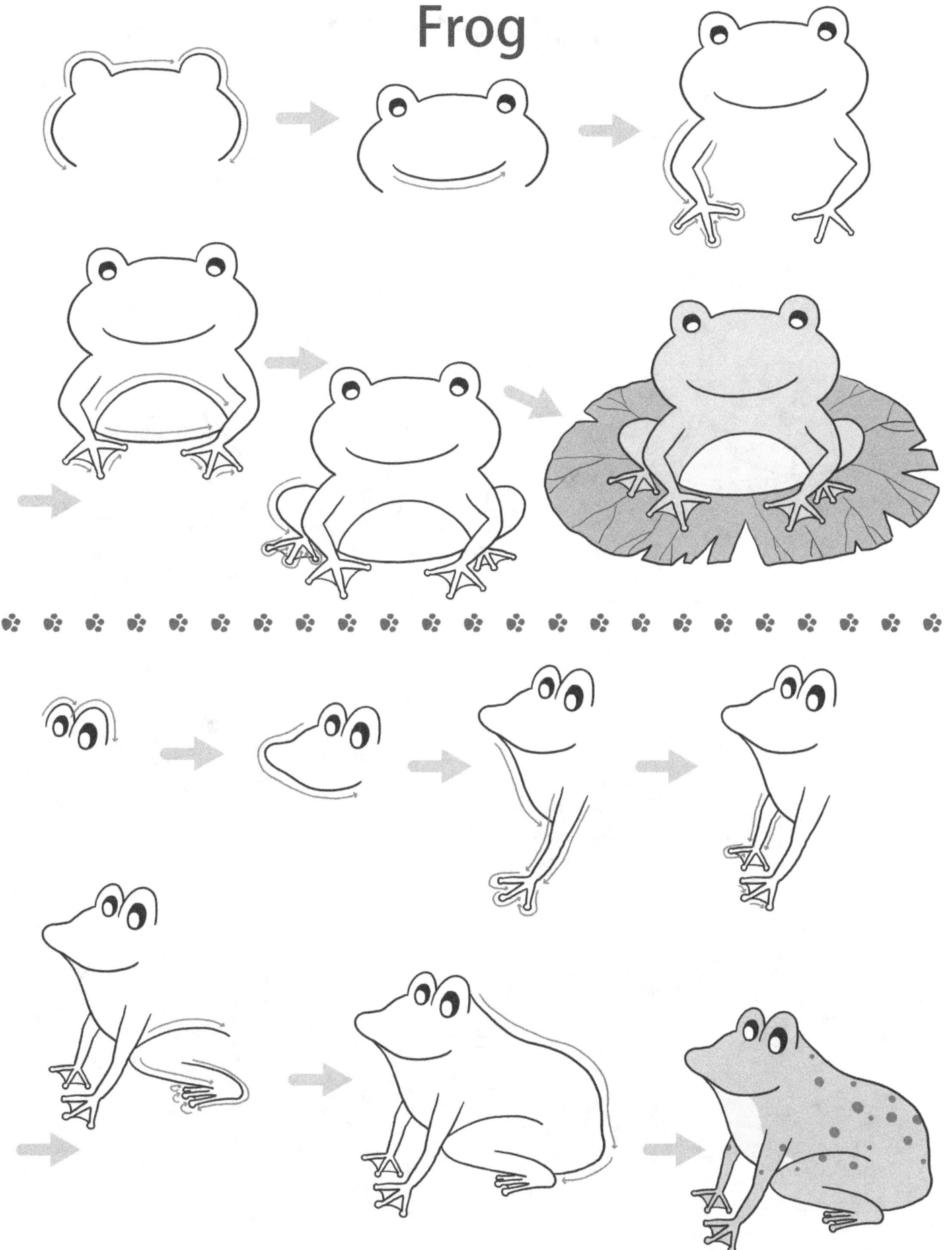

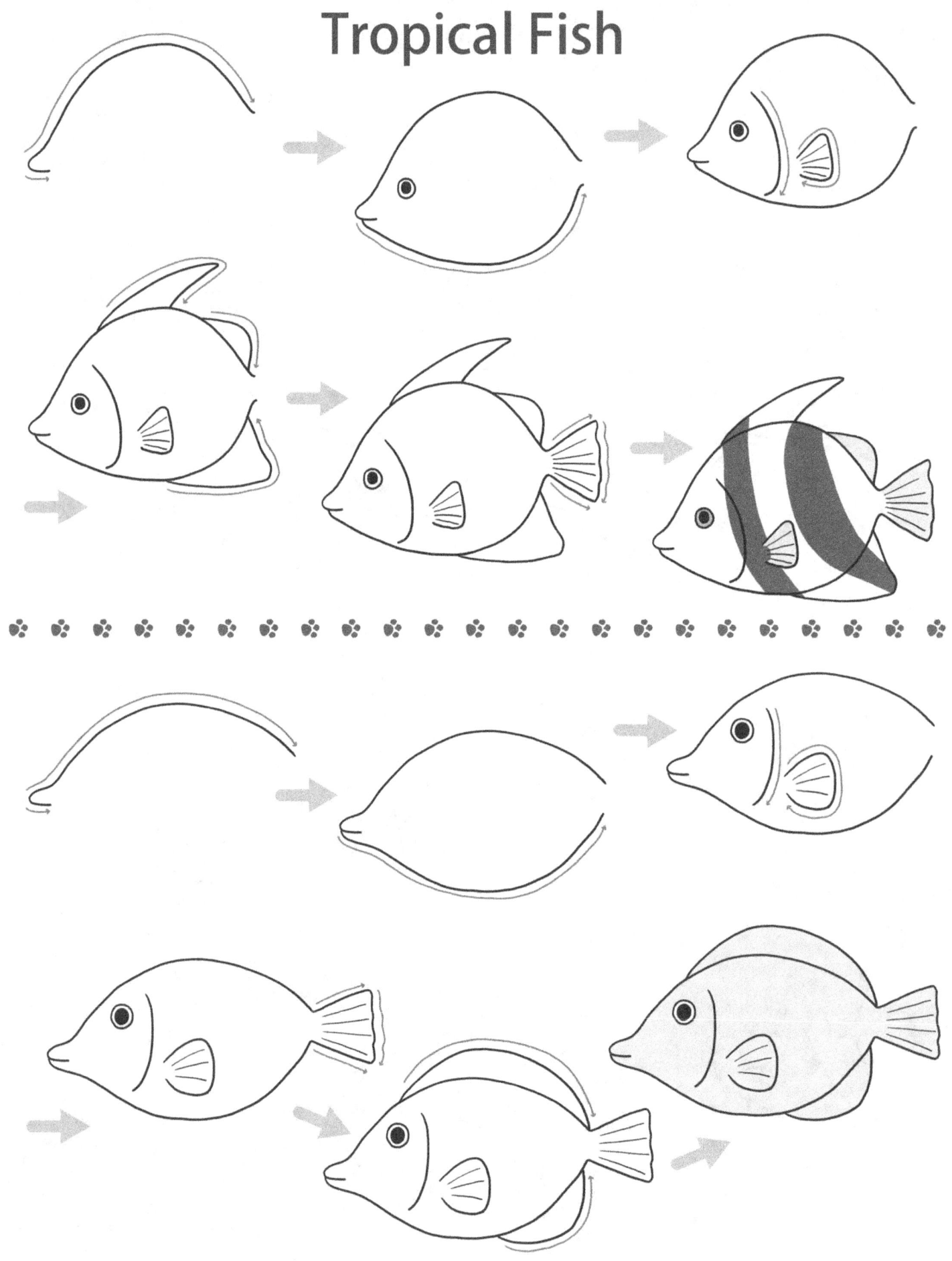

Goldfish

Fish

Pufferfish

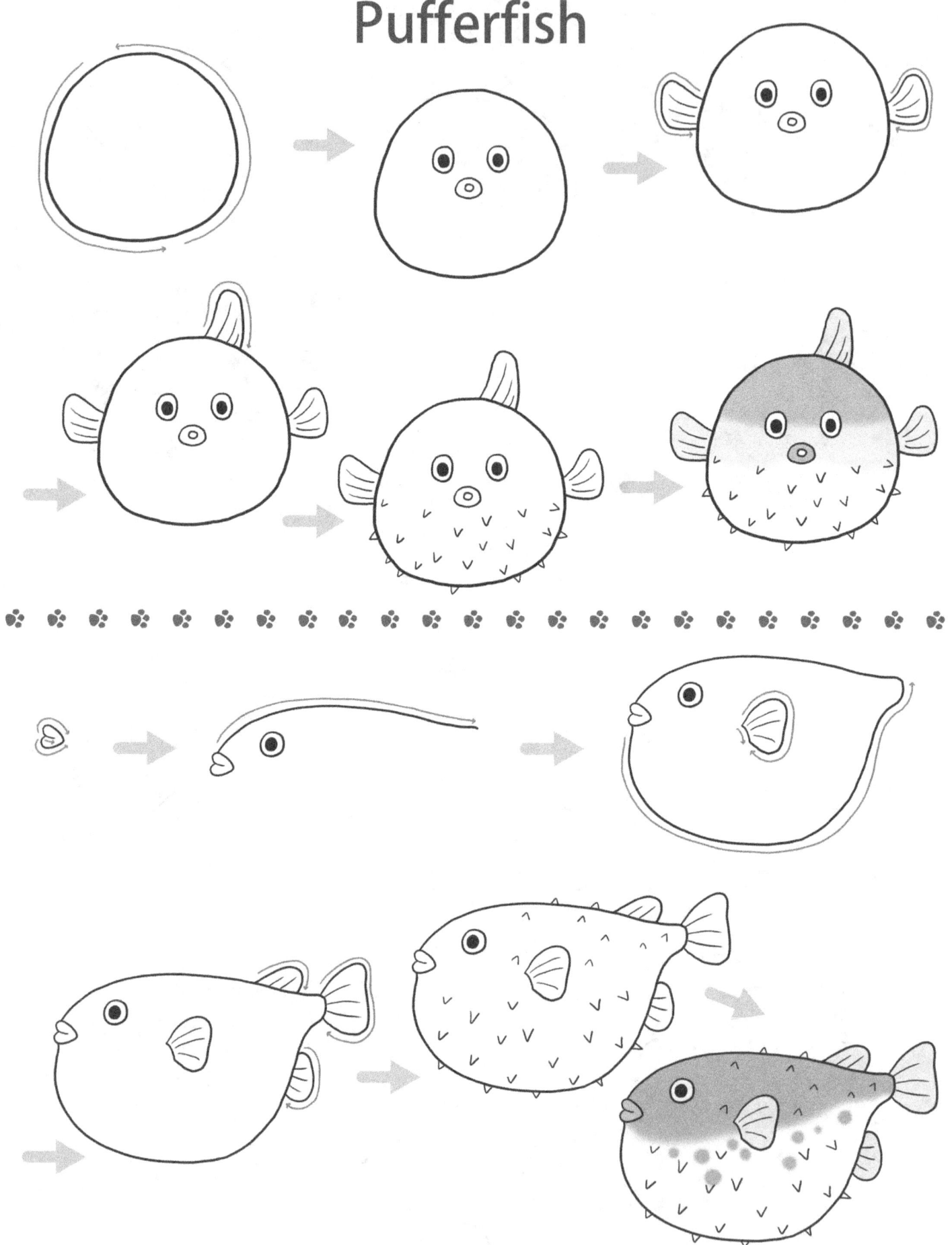

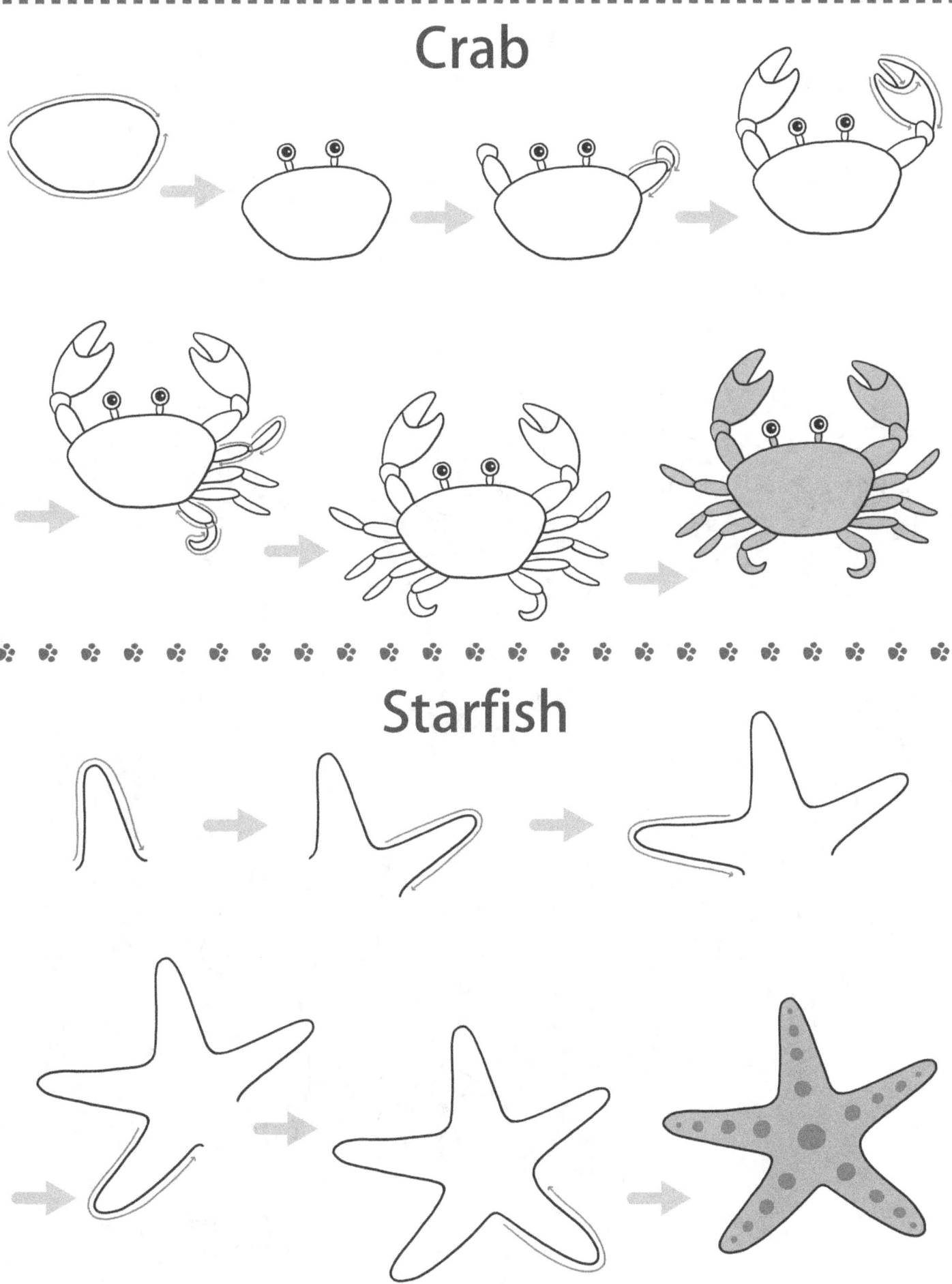

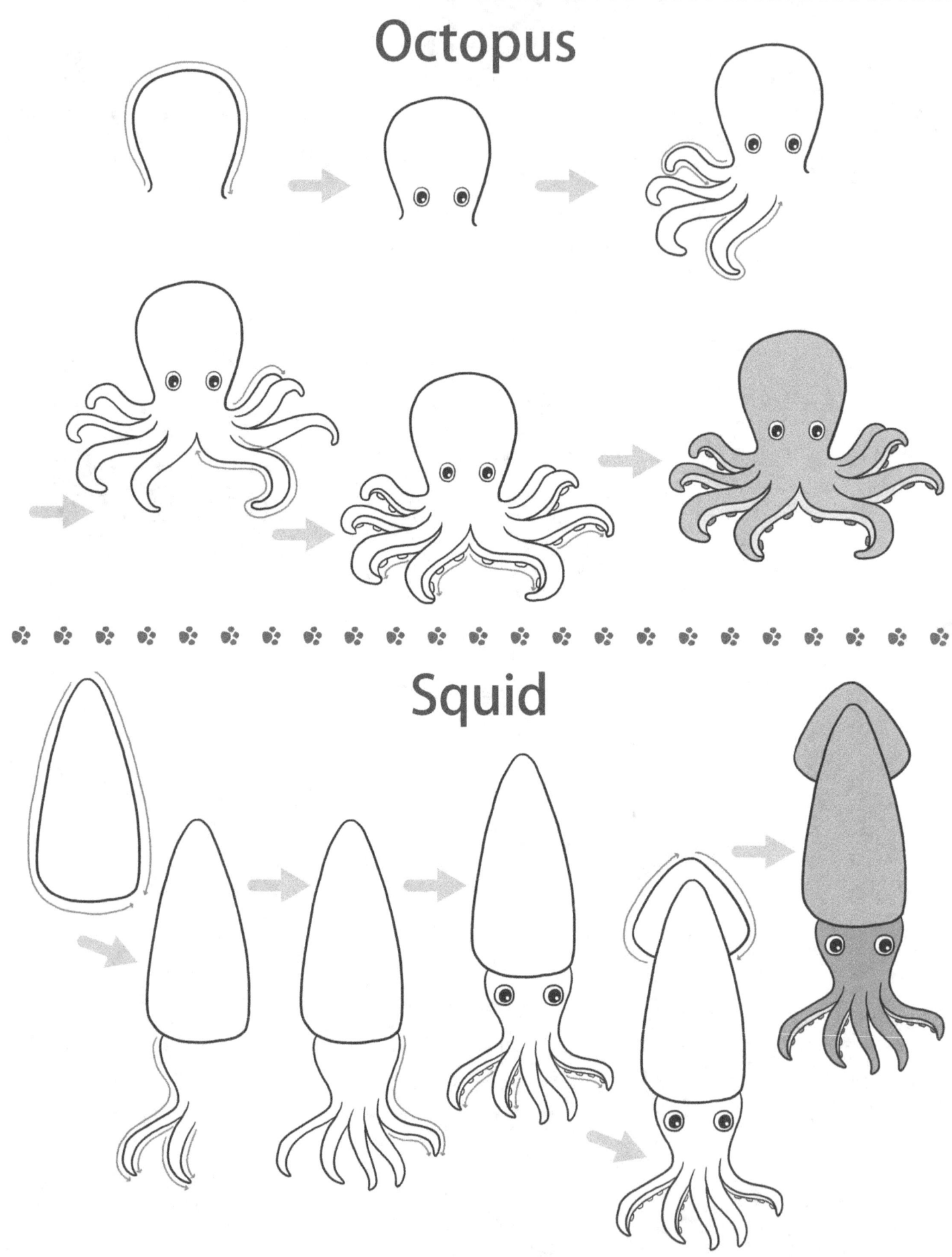

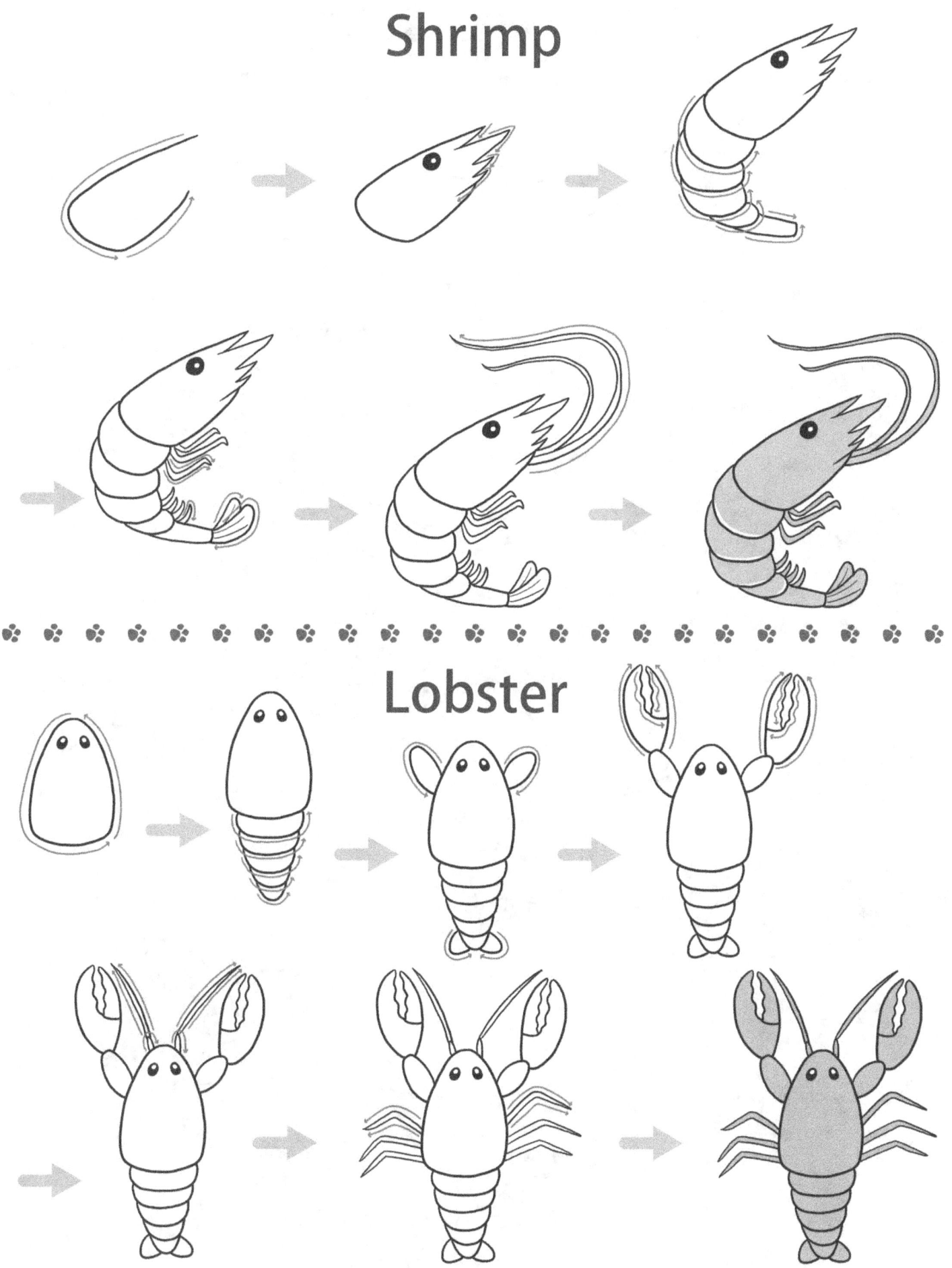

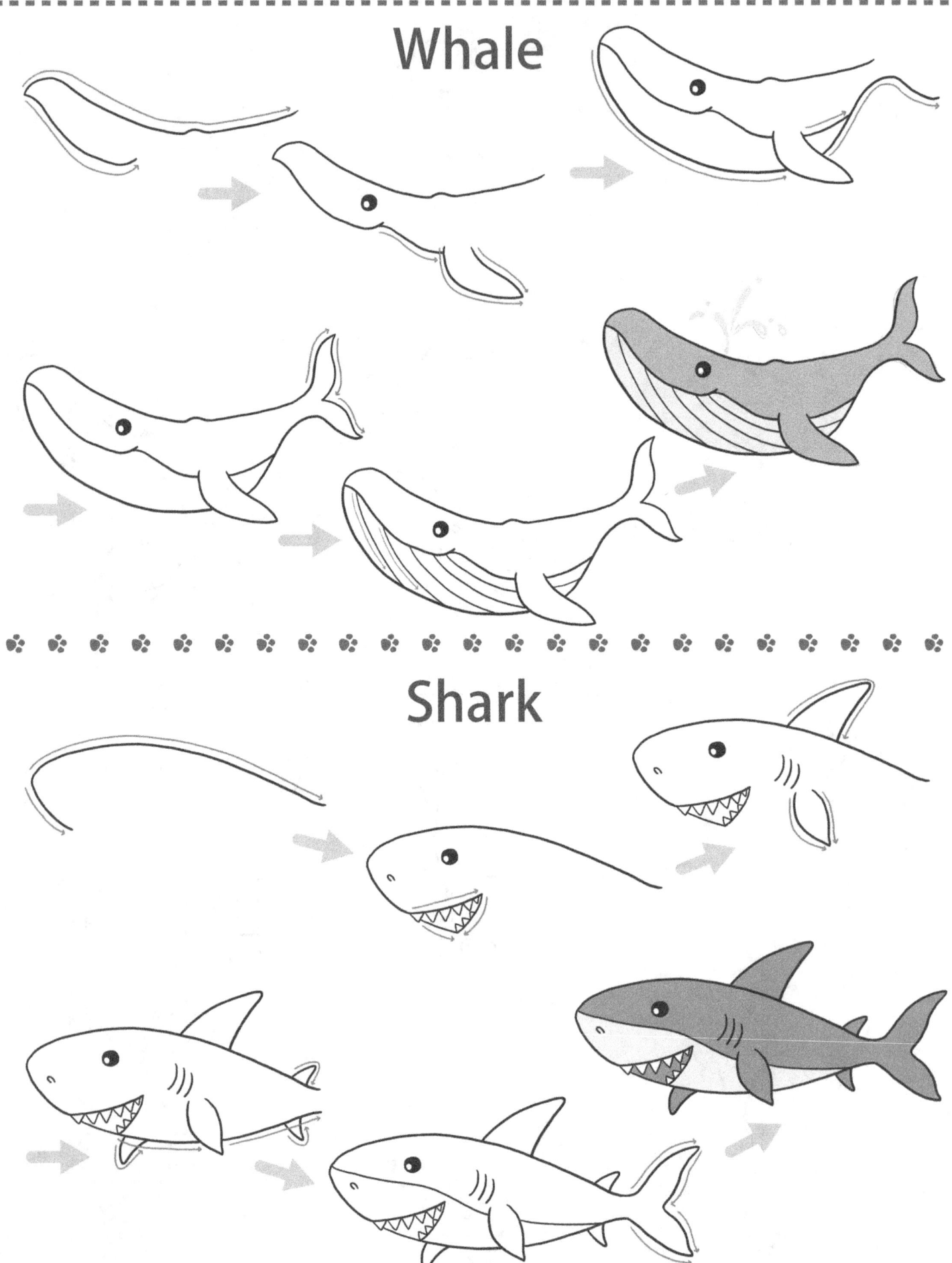

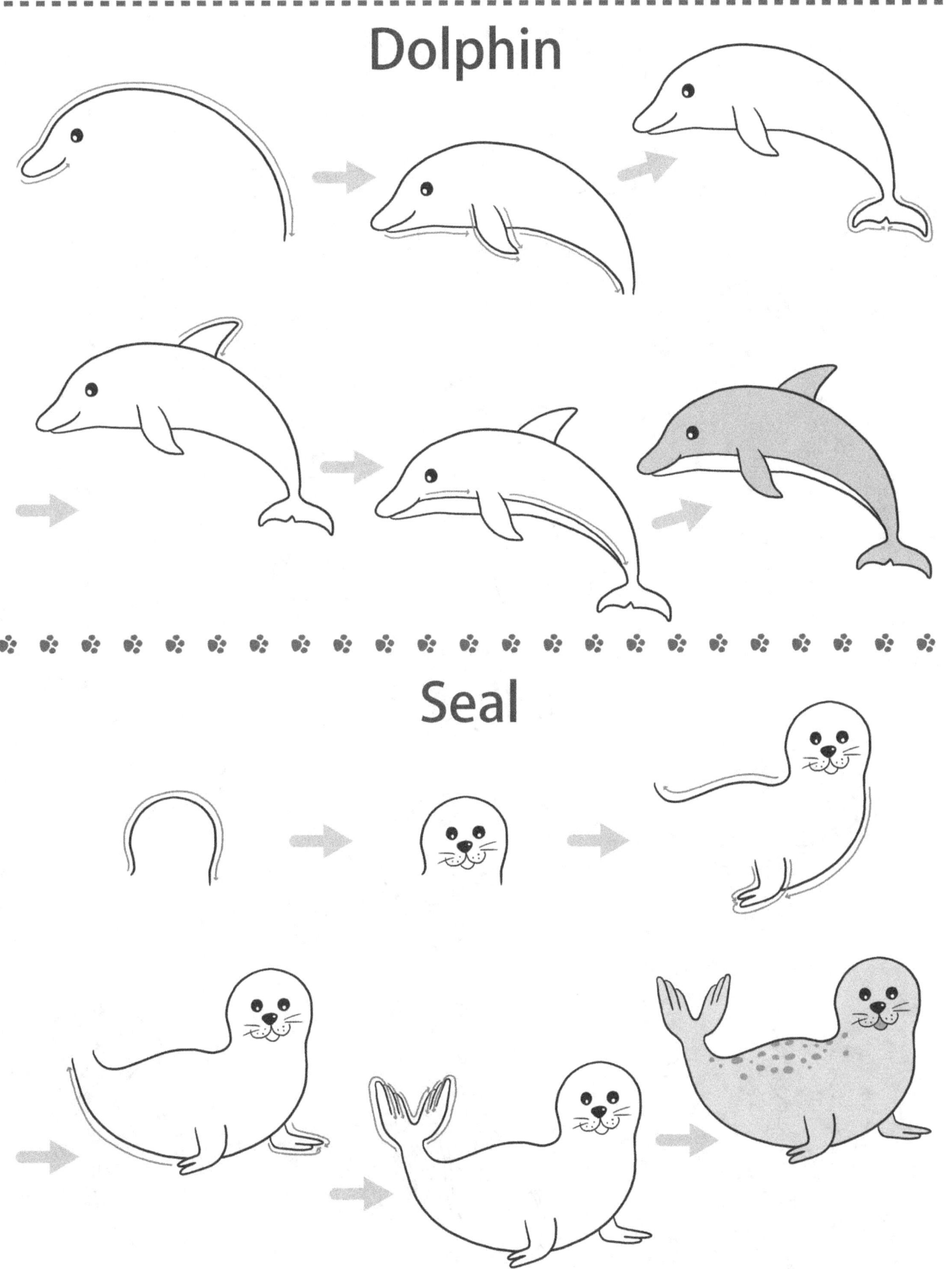

Seahorse

Jellyfish

Shellfish

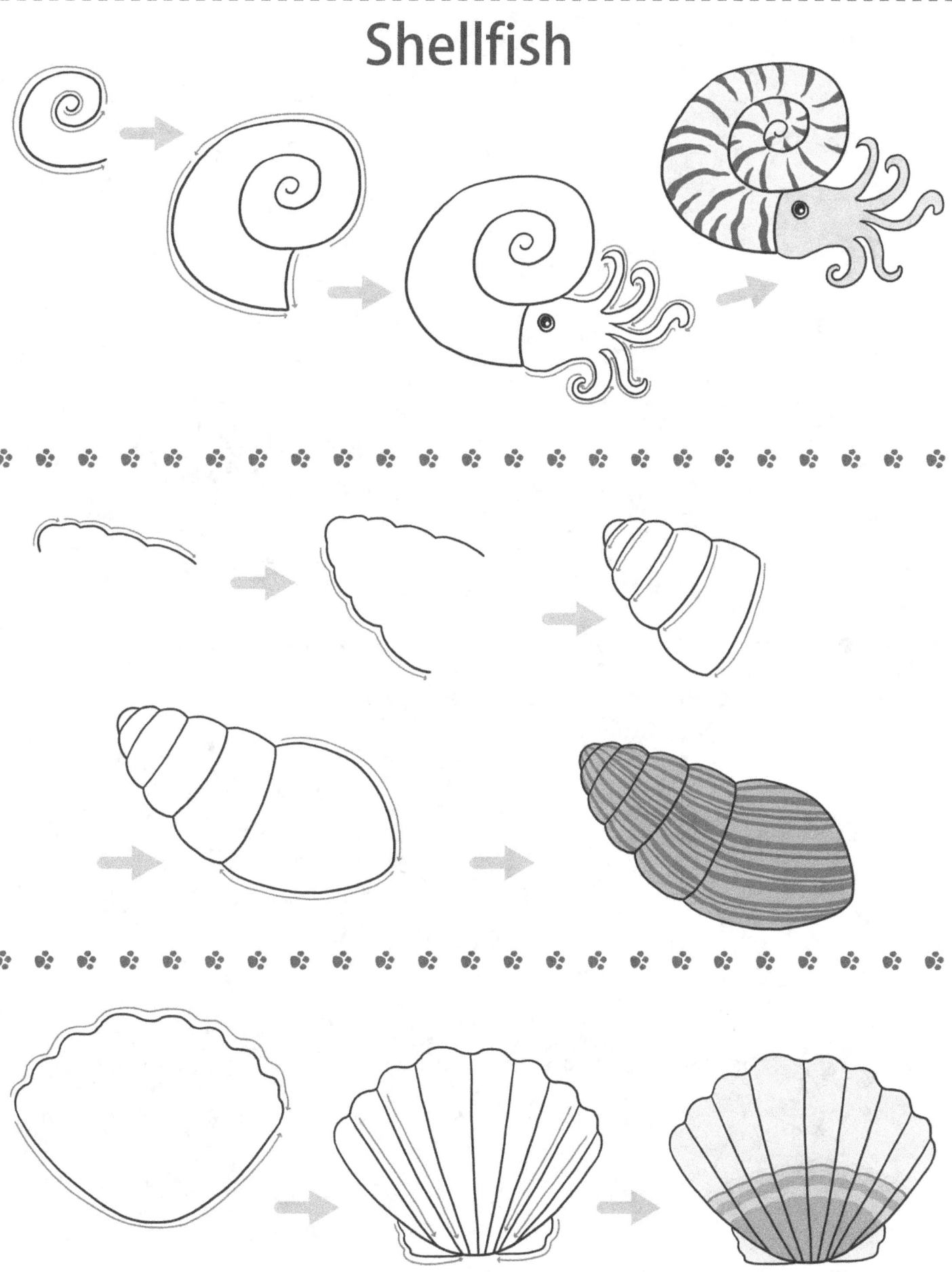

Snail

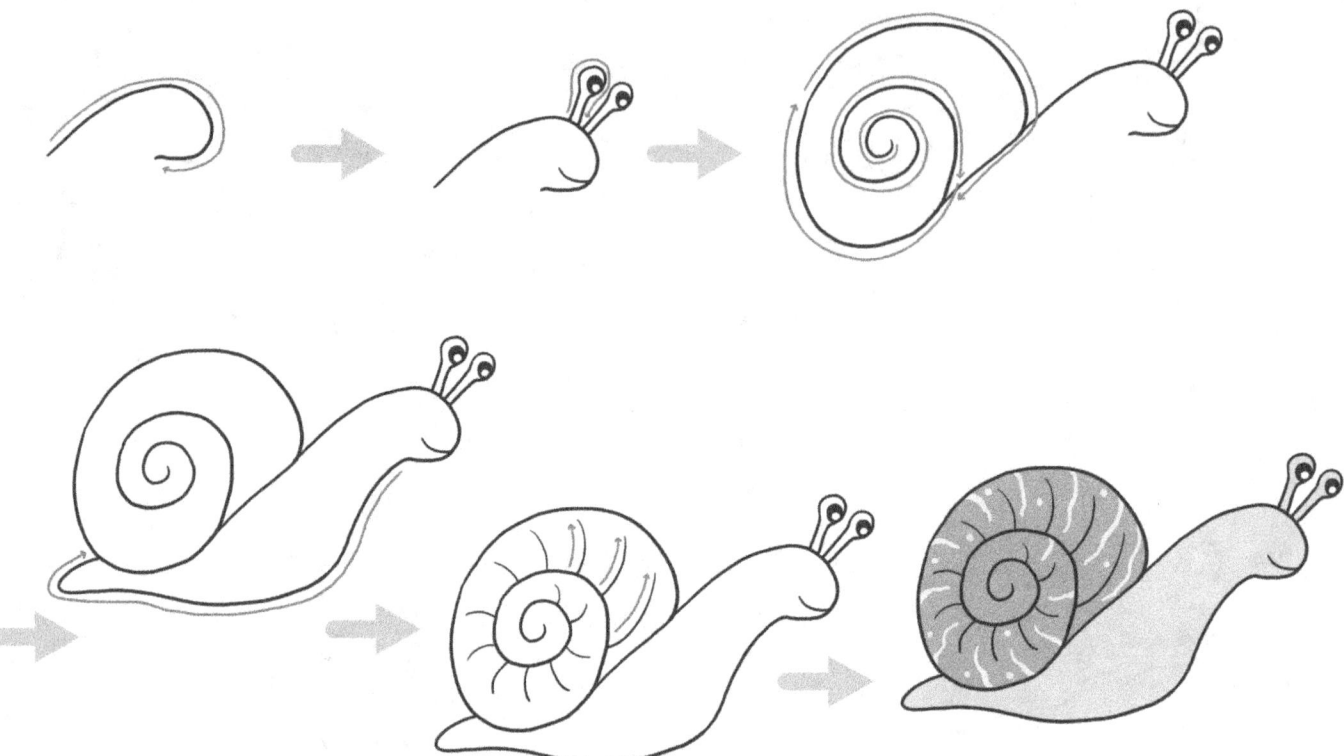

Ladybug

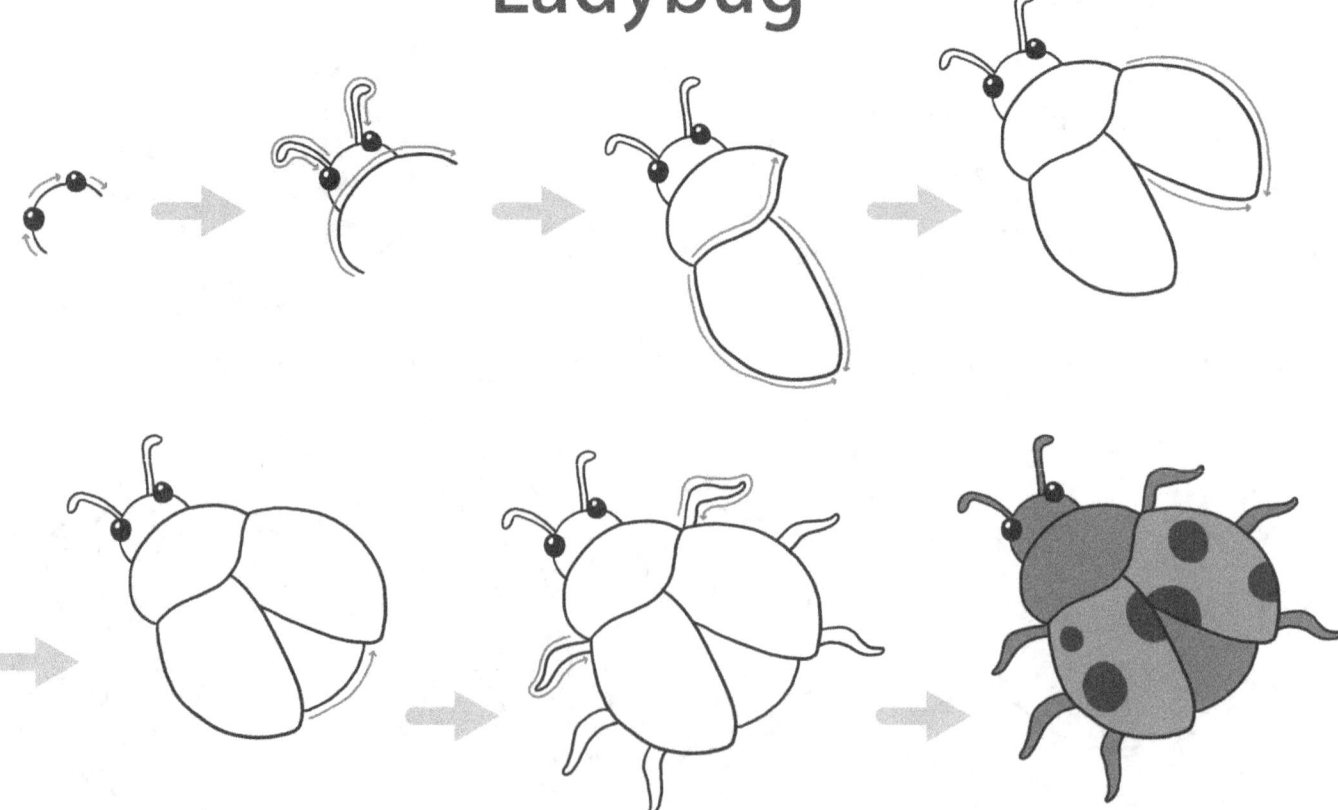

Butterfly

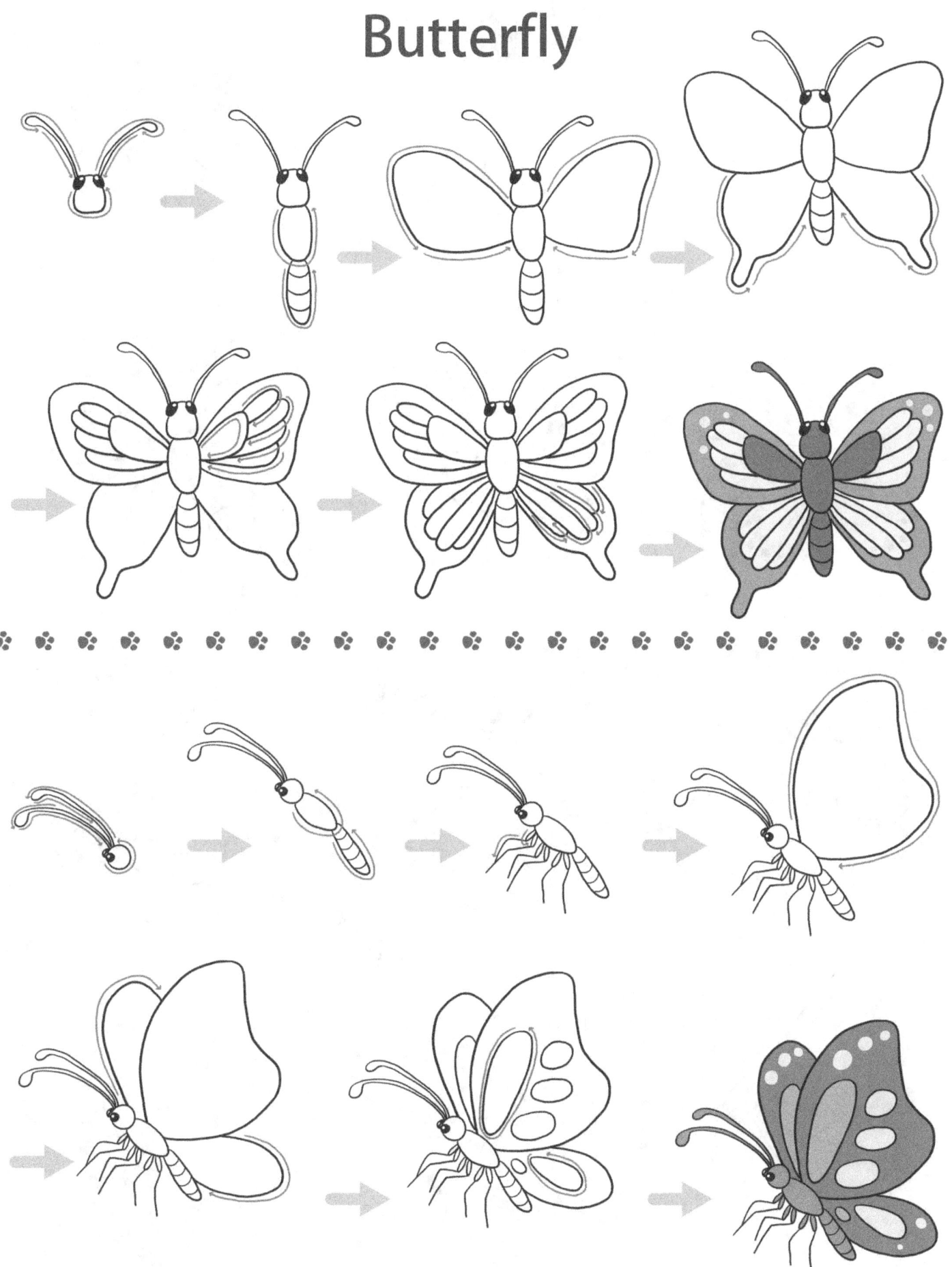

Bee

Dragonfly

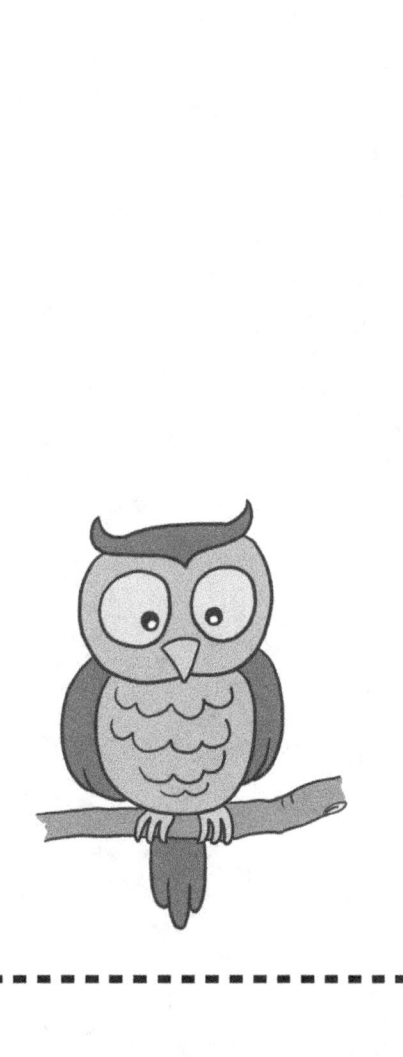

www.ingramcontent.com/pod-product-compliance
Lightning Source LLC
Chambersburg PA
CBHW080909220526
45466CB00011BA/3523